FOR THE LOVE OF STYLE

OF STYLE

Edited by
Corinna Williams & Nina Zywietz

teNeues

CONTENTS

PREFACE

First things first: We love to shop!

Sometimes, though, that's not as easy as it sounds. As we had to find out during our last trip to Los Angeles. The plan was to conceive of a concept for this book. One night, we decided to venture out of our writers' hideout. Destination: Santa Monica Place, an outdoor shopping mall. No, we hadn't come to window shop. We knew exactly what we wanted: new Vans slip-ons, classic white t-shirts by Gap, Nike running outfits. "We got this!" was what we thought. After just five minutes, we knew better.

The place was unpleasantly packed, the Nike windbreaker we wanted not on sale but still regularly priced at 90 dollars, even the right t-shirts were out of stock. Zero shopping bags in hand, we entered a skater store on the corner. Hallelujah! The bandana socks we spotted as soon as we walked in the door had us rejoicing. Even the Vans we wanted were right there on the shelves—albeit only in men's sizes. And when we enviously asked the pimply teenager at the cash register where we could get that very rad pine green Thrasher hoodie he was wearing, he just mumbled, "Sold out." Our good spirits? Crushed, yet again.

Ok, we could have scoured the internet or even sent an email inquiry to skateboard zine, *Thrasher*. But the fact is: Either would have taken up way too much of our time. After all, we still had to facetime with our families in Belgium and Germany, go for a run on Venice Beach, and work on said book project.

By now you're probably asking yourself why we would even write a book about something that we obviously have difficulty dealing with at times.

Because we a) believe that it's getting harder and harder for all of us to find our personal, unique style. Journals report on hot new labels every week; more and more celebs turn designers—sometimes surprisingly good ones; countless online newsletters and shops continue to tempt us with their best buys of the week, month, season… So, where to go to order our Vans? Would it make more sense to hit a store in Berlin or New York? And then, does the model we want also come with a black sole instead of a blue one? Maybe, we're at a point in our adult lives where we should move on to something more sophisticated—let's say, a Gucci loafer—altogether? By the time we've figured that out, at least two hours of internet research will have gone by, yet we won't be any closer to scoring the shoes we want.

In order to avoid situations like these, we could b) turn this book into somewhat of a manual, we figured. In the end, we, as creative director for various fashion labels and lifestyle journalist, know where to find the white turtleneck the stylist we work with wants to have peek out under a slip dress at a fashion shoot or which New York jewelry designers happens to carry just the right kind of ear cuff this season. Over the years, we c) have—between the two of us—built a network of industry insiders, many of whom were happy to lend their support for this project. We asked the designers at M. Martin what they consider wardrobe staples for the minimalist dresser; Tory Burch how to recreate her relaxed all-American Look. Plus, street style pros like Tamu McPherson showed us what key pieces will transform a run-of-the-mill outfit into creative styling.

For every influential style we selected our Big 5 designers, plus 3 who have set out to reimagine their looks. That was—hands down—a lot of fun. Because we discovered many innovative and exciting things. Our new favorite label is M. Martin. And we would, as of now, love to be dressed by denim newcomer R13, thank you! We promise to wear their jeans with a Prada backpack, an Acne coat, the bandana socks from the skate shop and a short-sleeved version of the Thrasher sweater we, after all, were able to find on the internet…

For the Love of Style

Corinna & Nina

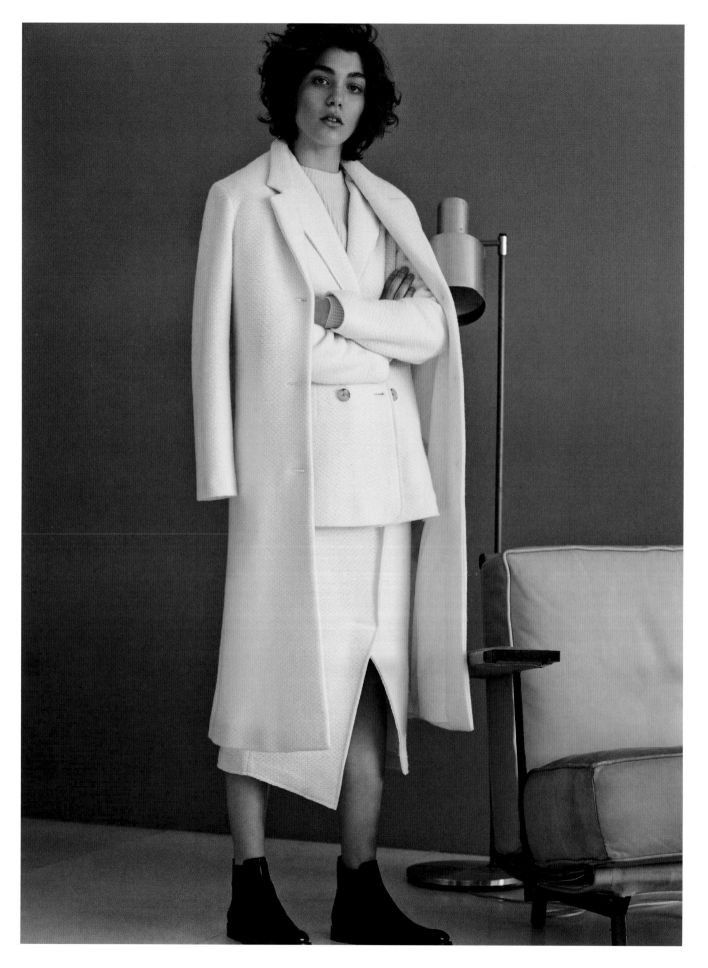

«I'm convinced there is luxury in simplicity.»
Jil Sander

PURE

"She is a woman who expresses elegance through a sense of ease"—that's how the designers at M. Martin describe their typical customer. The muse for this young New York label's fabulously simple collections is none other than Coco Chanel. "We fell in love with the photo of Chanel in her pajamas and we wanted to create a lifestyle around it. It was from there we created the idea of a 'day suit' built from soft separates like oversized knits, soft blazers, and cashmere wrap coats," explains M. Martin's Jennifer Noyes. "As comfortable as pajamas, but chic enough to throw on for a dinner party." With her casual style, Chanel was years ahead of her time. Cue the little black dress, a radical departure from the prevailing dress code. Unadorned, plain, short, black—which was frowned upon as absolutely frivolous at the time. Nevertheless, *Vogue* in 1926 declared the simple dress a "must" for the modern woman because it represented women's liberation from beauty standards imposed by men. Speaking of men, Chanel was also known to help herself to pieces from her lovers' closets on occasion. Many of the female designers featured in this chapter would happily admit to doing the same. "Pretty masculine" is how Phoebe Philo of Céline characterizes her personal style for the British *Independent.* "That's how I dress and I think it's quite liberating for women not to have to be so preoccupied with different silhouettes." This sense of reduction, which is typical for many men's closets, not only applies to the design aesthetic of many of these women, it has become a way of life for them. That certainly rings true for Ryan Roche, who withdrew from the fashion clamor in New York City to the idyllic mountains of New York State—where she creates incredibly beautiful knitwear reduced to the very basics: plain cuts, exquisite materials. Pure and simple!

ESTABLISHMENT

The Big 5

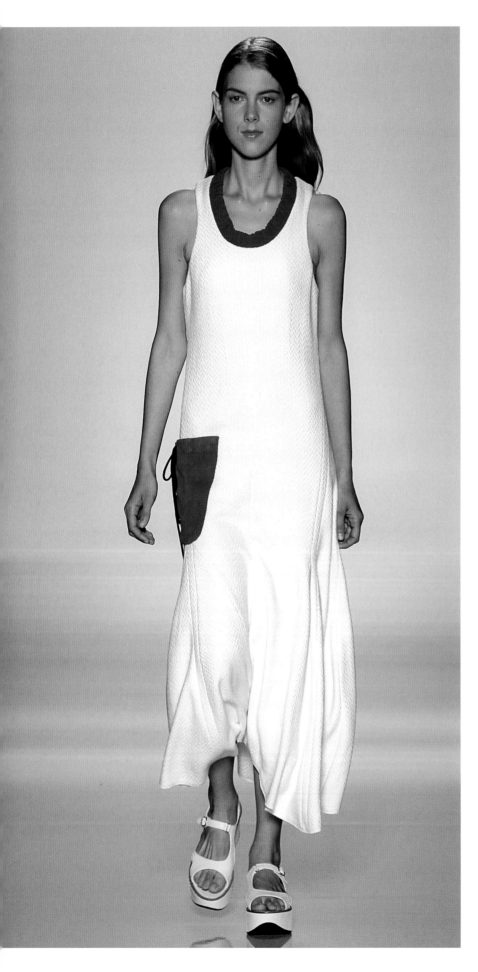

VICTORIA BECKHAM

Veering from her initial body conscious attempts at fashion design in 2009, Victoria Beckham has since taken a quantum leap towards relaxed, simple, and above all, cool elegance. Good riddance, sexy silk slips in hourglass silhouettes. Farewell, eight-inch stilettos. Today, Posh Spice churns out drapey mid-length skirts, precisely tailored vests, and trousers with (who would have thought?) loafers and flat sandals, as well as the occasional baseball cap.

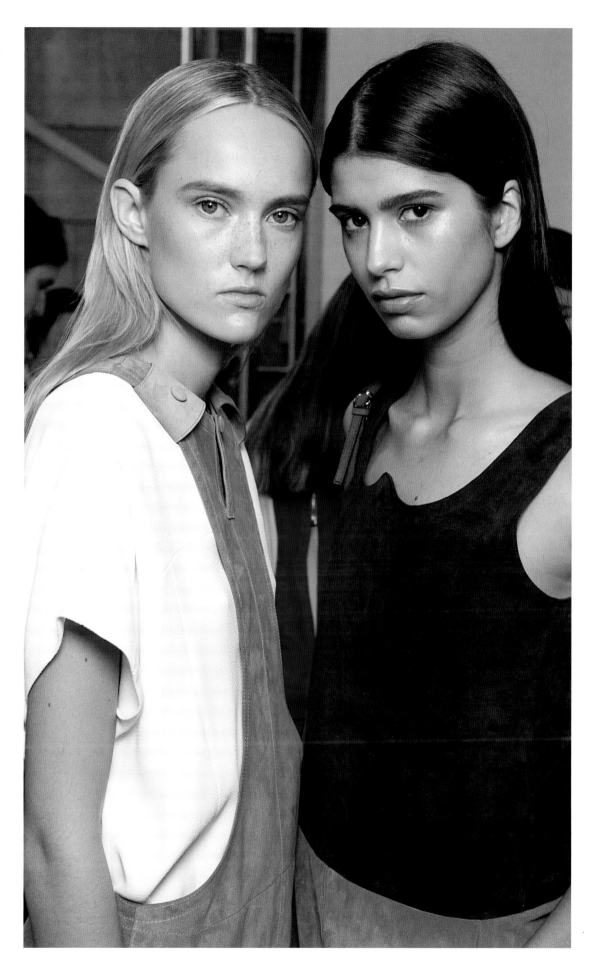

«I thought it was time for a more back-to-reality approach to fashion, clothes that are beautiful, strong, and have ideas, but with real life driving them.»

Phoebe Philo

CÉLINE

What do women want? Phoebe Philo knows! Dedicated to dressing herself in a uniform of Stan Smiths and turtlenecks, the creative director has overlaid the Parisian house's look with her menswear-based personal style. The Céline code: wide-leg pants, collarless shirt, smoking jacket, and flats. Quiet, wearable basics Ms. Philo will play up with statement accessories like her bestseller Trapèze Bag.

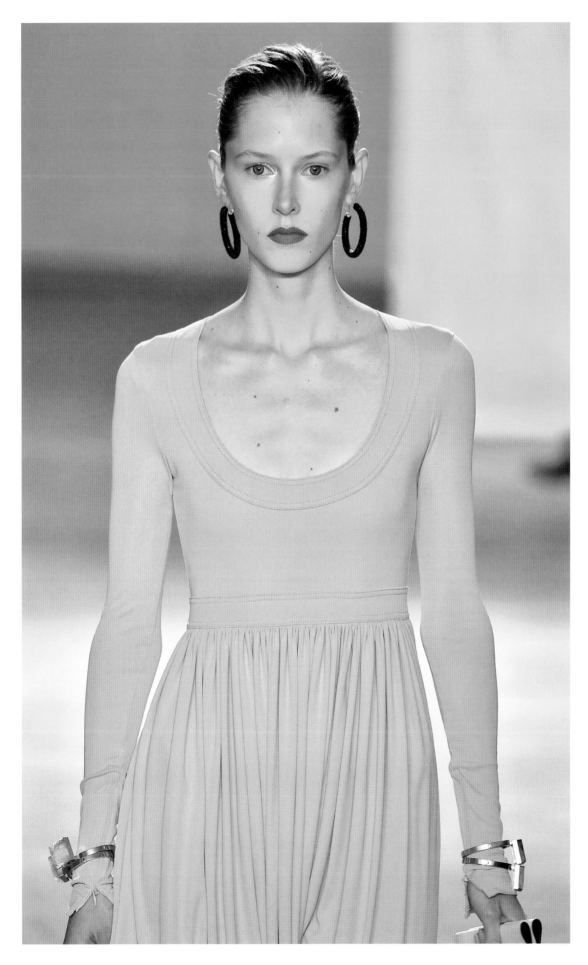

Paris,
Spring/Summer 2016

No. 3

JIL SANDER

Jil Sander has always been the epitome of pure chic. To this day—that is: two comebacks, three departures from her own label later—the Queen of Clean is still feted as one of the biggest German fashion designers of all times for her precisely tailored classics (white shirt, blazer, ankle-length trousers). Her heirs: Raf Simons, on a seven-year stint as Sanders creative director starting in 2005. And, as of late, Rodolfo Paglialunga, who was last seen loosening up the house's strict lines with whimsical asymmetries in one-shoulder blouses and cutout dresses.

Milan, Fall/Winter 2015/2016

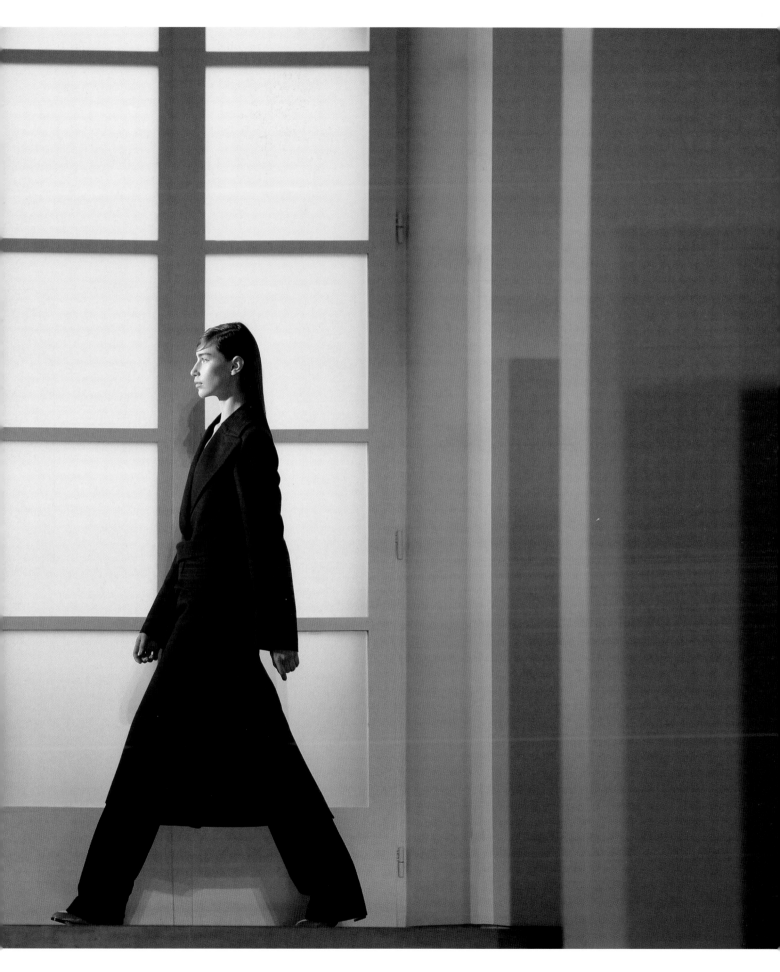

No. 4

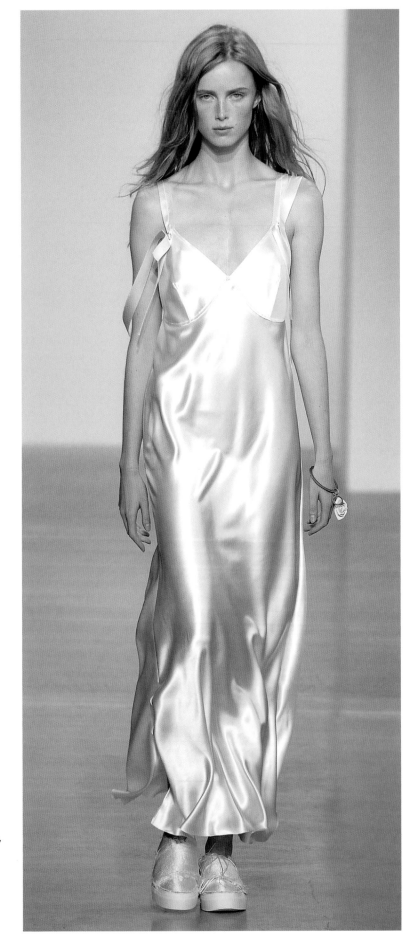

CALVIN KLEIN COLLECTION

During the nineties, nobody mastered the art of
distilling fashion zeitgeist (grunge) through their
personal (pure) filter quite like Calvin Klein.
The result? Modern fashion sans drama or prints,
a reduced sense of elegance, tomboy chic.
Francisco Costa, who took over the reins in 2004,
has been known to occasionally revisit Klein's
signature piece, the long silk slip, along with
slim pants and his predecessor's classic
masculine coats.

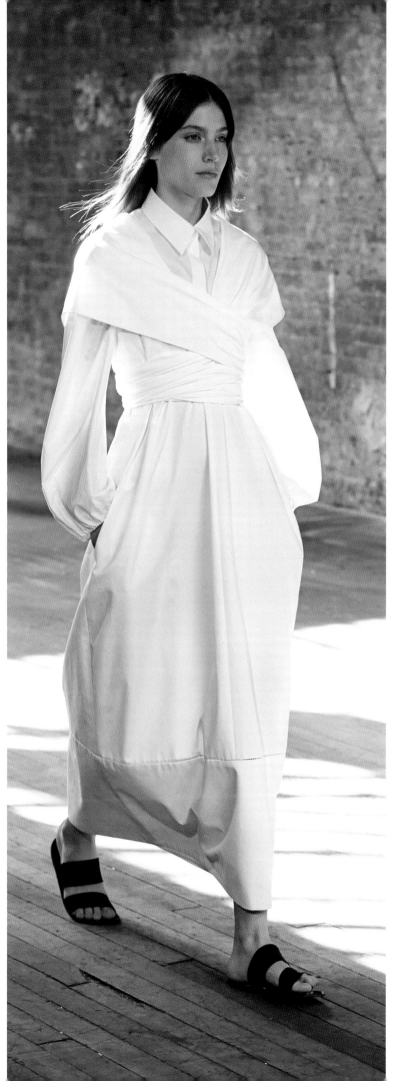

THE ROW

A minuscule alligator skin backpack ringing in at a humble $39,000. And sold out almost instantly. What could easily describe a tale of a waitlisted bag at Hermès was a fantastic feat The Row pulled off after a mere five years in business. The label, run by twins Mary-Kate and Ashley Olsen, has since become a synonym for simple yet super-luxe womenswear: floor-skimming satin dresses and oversize double face coats in black, white, crème and navy. Understatement made in New York.

TRENDING

3 To Watch

Ryan Roche

20

M. Martin

22

Ellery

23

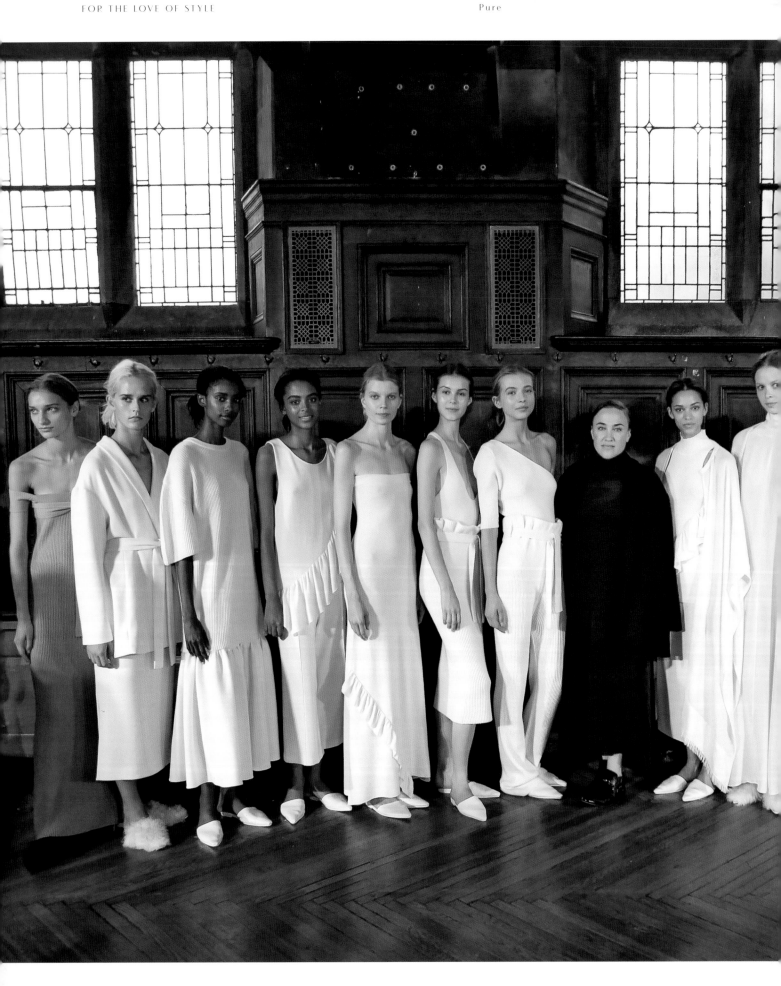

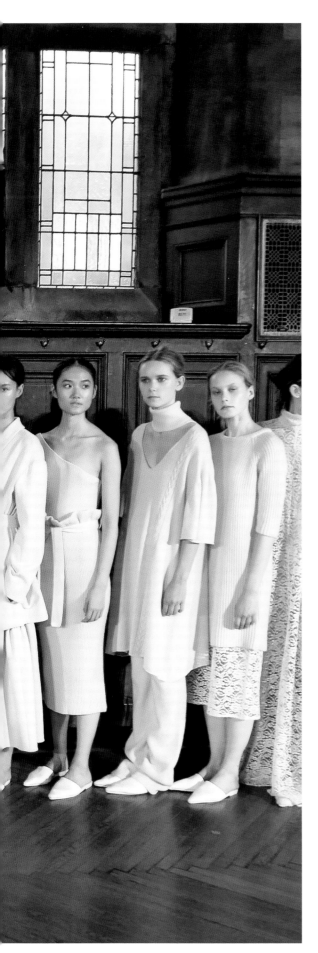

No. 1

RYAN ROCHE

"Every woman needs a hero in her closet," says Ryan Roche. Which is why, far removed from the world's big runways, ensconced in her studio in the Catskill Mountains, she creates exactly that: heroes. Pieces like clean cashmere ponchos, super soft oversize sweaters and knit dresses you will never want to take off. Even better? Their subtle color palette makes those heroes uncomplicated wardrobe staples: off-white, beige and the American designer's personal favorite—blush.

New York,
Fall/Winter 2015/2016 (right)
Spring/Summer 2016 (left)

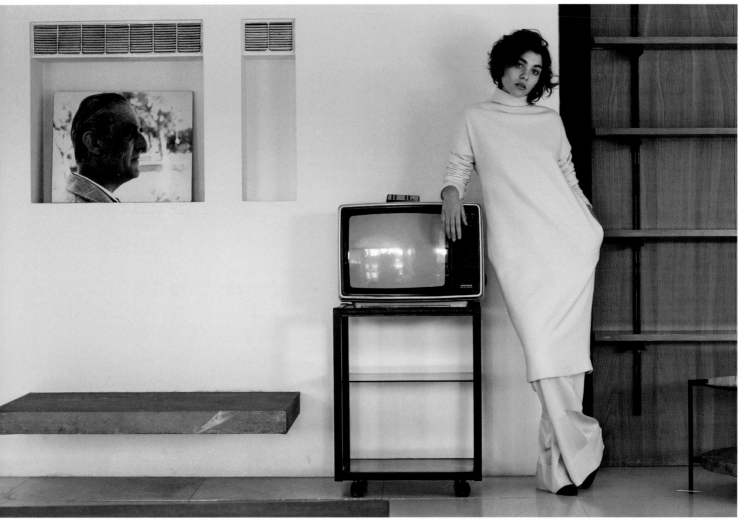

**Fall/Winter
2015/2016**

No. 2

M. MARTIN

What happens when two veterans of the fashion industry, who both happen to be working moms searching for practical wardrobe classics that will last more than one season, meet? They create M. Martin, the new baby of Prada's former womenswear director Jennifer Noyes and Alex Gilbert, founder of denim label Paper Denim & Cloth. Their signature look: oversize knits paired with perfectly fitted trousers, menswear shirts and jeans, all wrapped in a simple cashmere coat. Done!

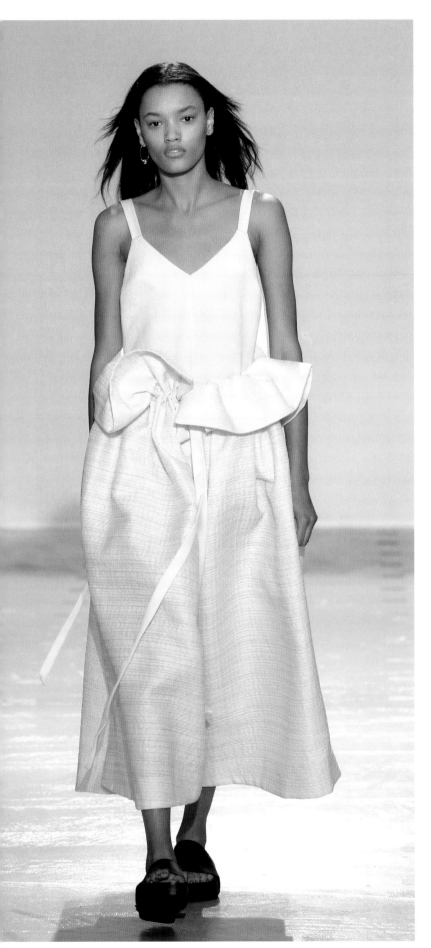

ELLERY

Her young label has propelled Kym Ellery all the way to the top of the industry watch list. Even if her designs, which she debuted internationally for spring 2014 in Paris, have yet to show a consistent leitmotif—there seems to be one recurrent key piece in her architectural collections to date: a pair of slim leg bell-bottomed pants that Ellery, a former fashion editor from Australia, pairs with voluminous vests, long blazers, simple tunics and sculptural tops.

**Paris,
Spring/Summer 2016**

NEVER WITHOUT

by Alex Gilbert & Jennifer Noyes

M. Martin

an oversize knit

a slouchy pant

a blanket coat

the perfect poplin shirt

the easy t-shirt dress

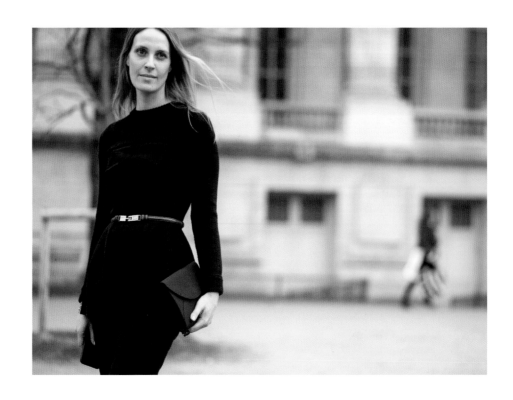

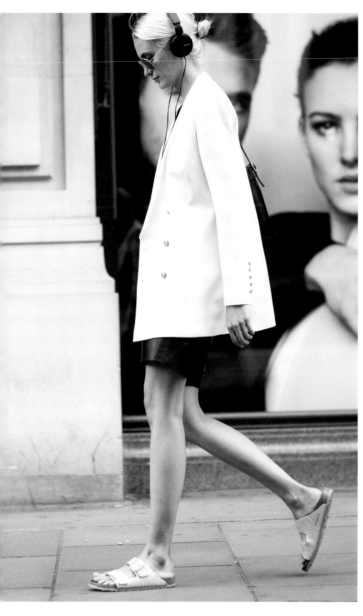

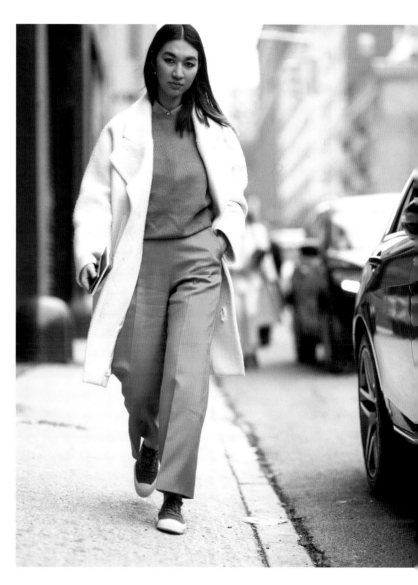

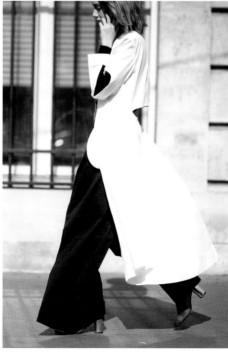

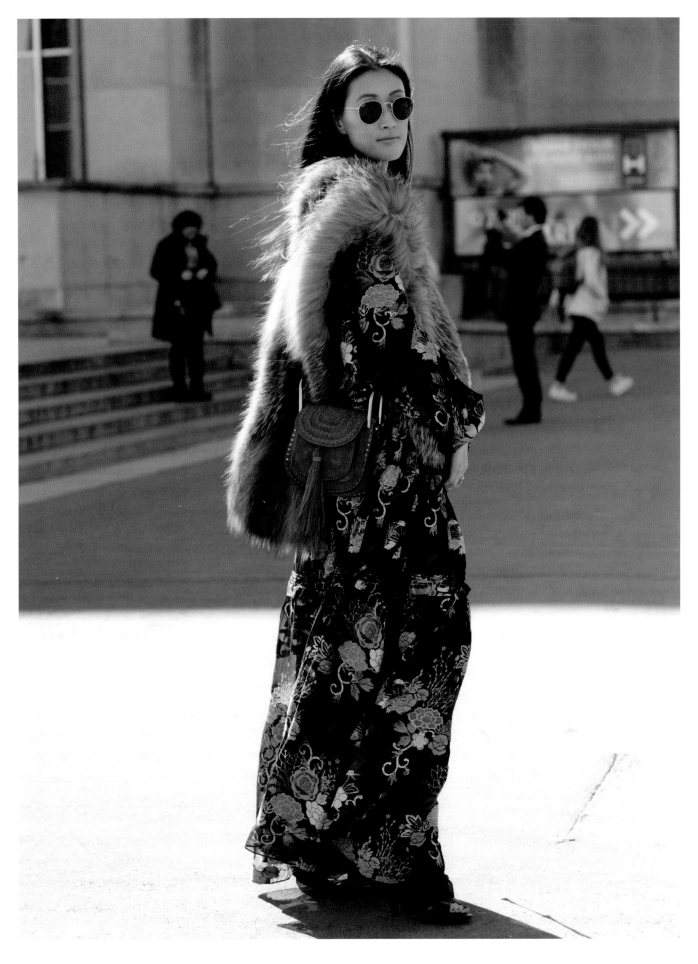

ROMANTIC & BOHEMIAN

Vanessa Seward lives in Batignolles, a hippie neighborhood in Paris, with her composer husband. Their apartment has crimson velvet armchairs competing with Chinese lacquered furniture, tapestries and vintage chests. Her lifestyle is quintessentially Bohemian: unconventional and free to pursue her interests in music, art and literature. Bohemians like Seward are never confined to one particular place. They're vagabonds. And even if their projects happen to tie them to a desk in one of the creative hubs of the world for a while, they are always left with a romantic yearning: for foreign continents, exotic languages, unfamiliar ways of life and a carefree existence. "She is someone who lives the nomadic fantasy and simply wants to weave dreams of Morocco or Tulum into her everyday city lifestyle," Kim Hersov describes the women who collect her modern hippie chic label Talitha's tunics (Find Kim's and business partner Shon's five must-have pieces for a Bohemian wardrobe on page 46). These are ladies who fill their closets and suitcases accordingly, with light chiffon dresses, tunics, ponchos with leather fringes, and lace-up sandals. Not to forget the jewelry they find on their travels. "We are influenced by women with holiday styles as influential as any catwalk collection. Marisa Berenson, Veruschka and Kate Moss. They are world travellers living on a whim, but always dressed for the most exceptional of eventualities."

ESTABLISHMENT

The Big 5

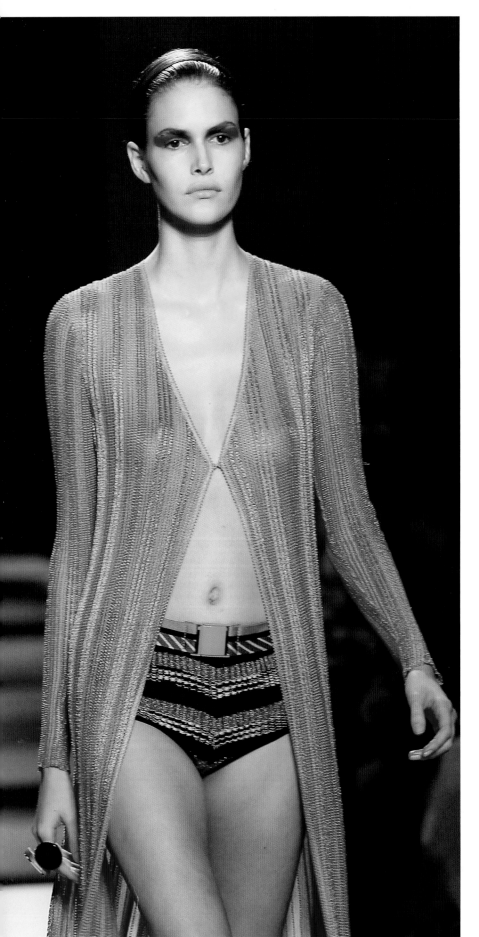

MISSONI

Introducing the first family of boho: Angela Missoni, who, along with her two brothers, took over their parents' (Ottavio "Tai" and Rosita) fashion business. Together with her daughter and society darling Margherita (the company's beachwear and accessories ambassador), she creates crochet looks in the signature zigzag pattern that gypsetters from Capri to St. Barth love to cover up their bathing suits with.
The company's best models? The Missonis themselves! Their 2010 spring/summer campaign featured the fashion clan members in their family label's designs.

Milan, Spring/Summer 2016

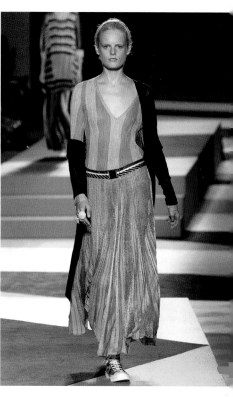

Milan,
Spring/Summer 2016

31

« When people meet me, they think this cannot be her, because I look like a bum. »

Isabel Marant

ISABEL MARANT

A pair of leather pants that fit like a glove, paired with a linen t-shirt and a chunky knit cardigan. Flat boots or the bestselling Marant wedge sneaker for good measure—done! Isabel Marant claims it takes her less than a minute to get dressed every day. Granted, she has all of the above-mentioned Parisian laissez-faire looks handy. There was indeed a time when that was not the case. So Marant decided, back in 1994, to start her own label, which has decked out her laid-back, like-minded peers ever since.

Paris, Spring/Summer 2016

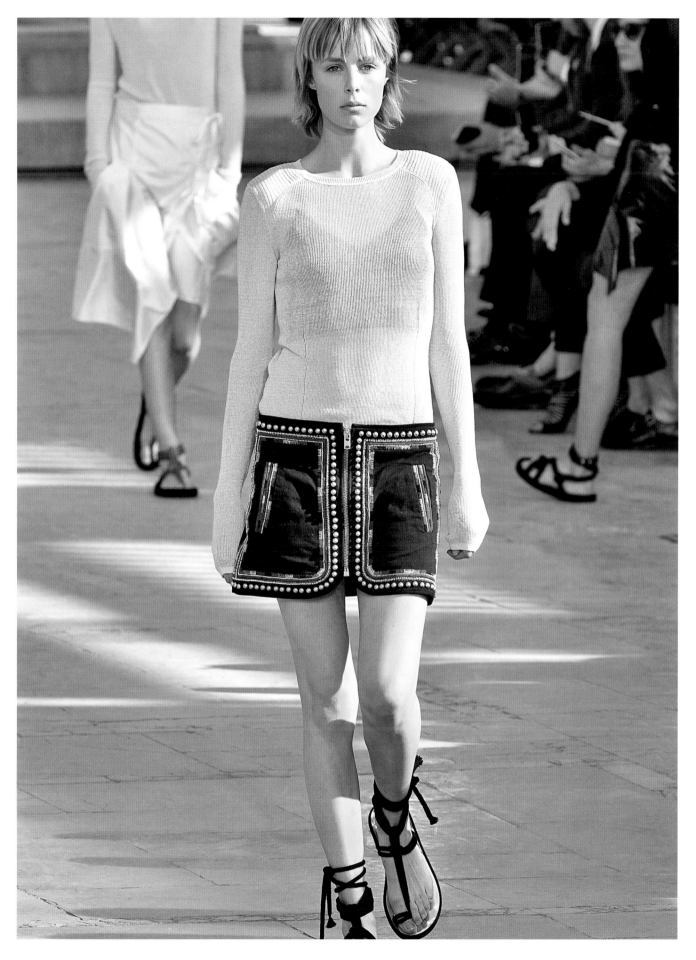

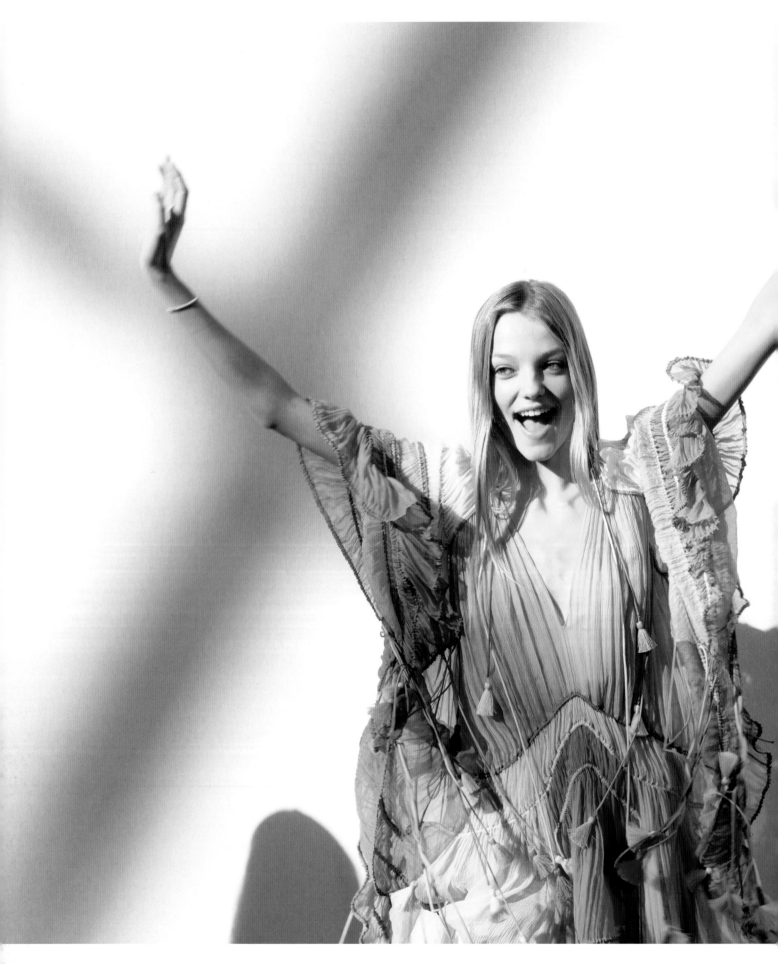

No. 3

CHLOÉ

Once at home in the seventies suitcases of jet-set icons like Grace Kelly, Brigitte Bardot and Jackie O., the looks of Chloé—to this day—clothe glamorous globetrotters looking to take resort-worthy chic to the Moroccan souk or outdoor restaurant in Tulum. A-line jean skirts, pussy bow blouses, broderie anglaise dresses: Whatever creative director Clare Waight Keller sends down the runway is bound to end up on the packing list of 21st century flower children.

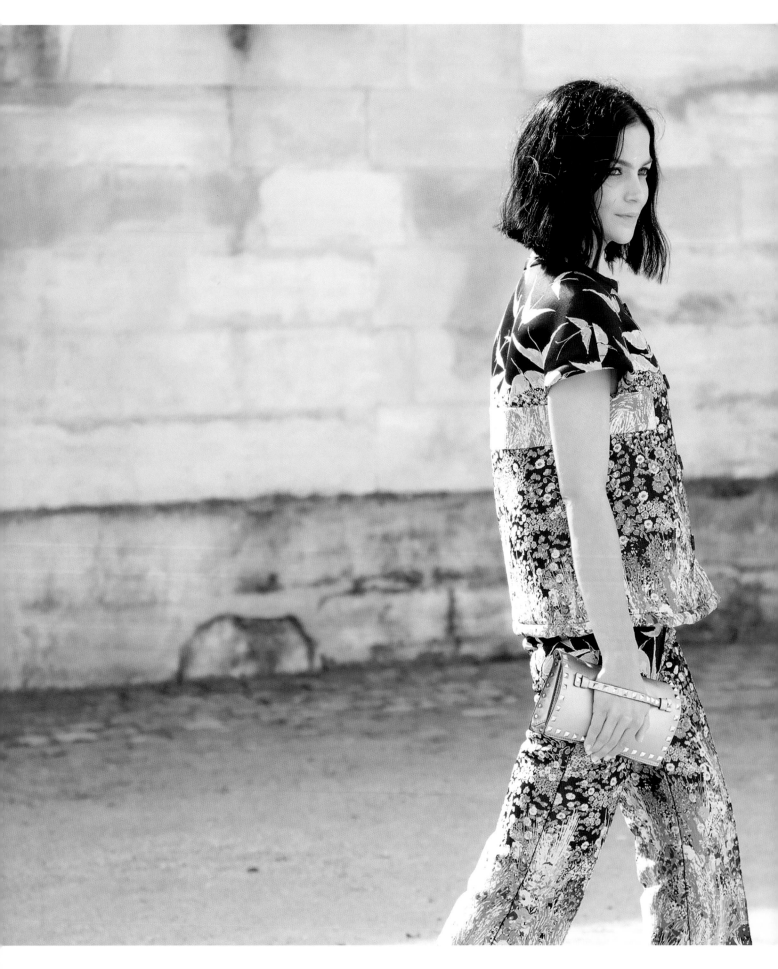

VALENTINO

Until 2007, the eponymous signor Valentino shaped the look of his house—designing primarily classic eveningwear which was glamorous and ladylike. Following the master's retirement, a previously unknown designer duo stepped in. Maria-Grazia Chiuri and Pierpaolo Piccioli breathed new life into the Valentino brand. Instead of classic eveningwear in the house's signature red, they've become known for dreamy renaissance style robes: long, delicate dresses with empire waists crafted from exquisite lace and ethereal chiffon.

Paris, Spring/Summer 2016

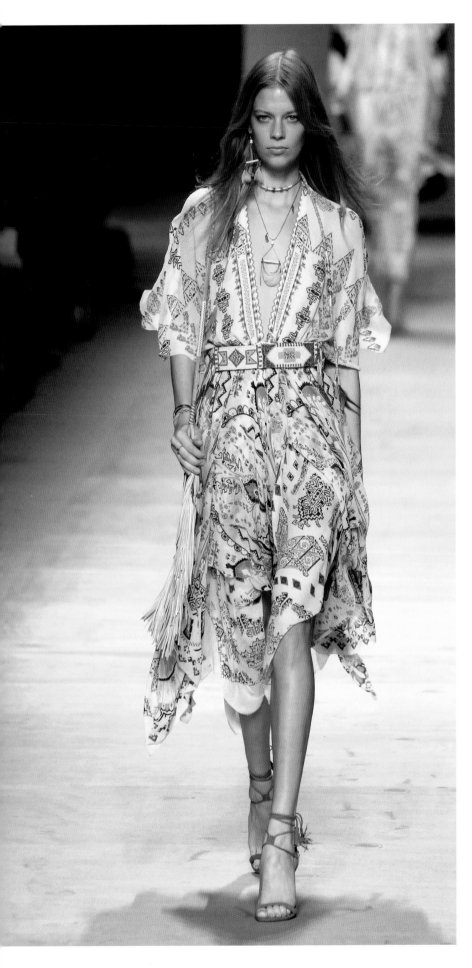

ETRO

Nothing screams "peace, love and boho chic" more than the paisley print Etro has made its own. The signature pattern embellishes everything from the label's flowing silk chiffon dresses to floor-skimming tunics and maxi skirts as well as XL shoppers carrying bathing suits and towels to the beach. What else? Fans of the Italian label complete their luxe folklore looks with an arm full of colorful jangling bangles and dangling ethnic chandelier earrings.

**Milan,
Spring/Summer 2015 (left),
Spring/Summer 2016 (right)**

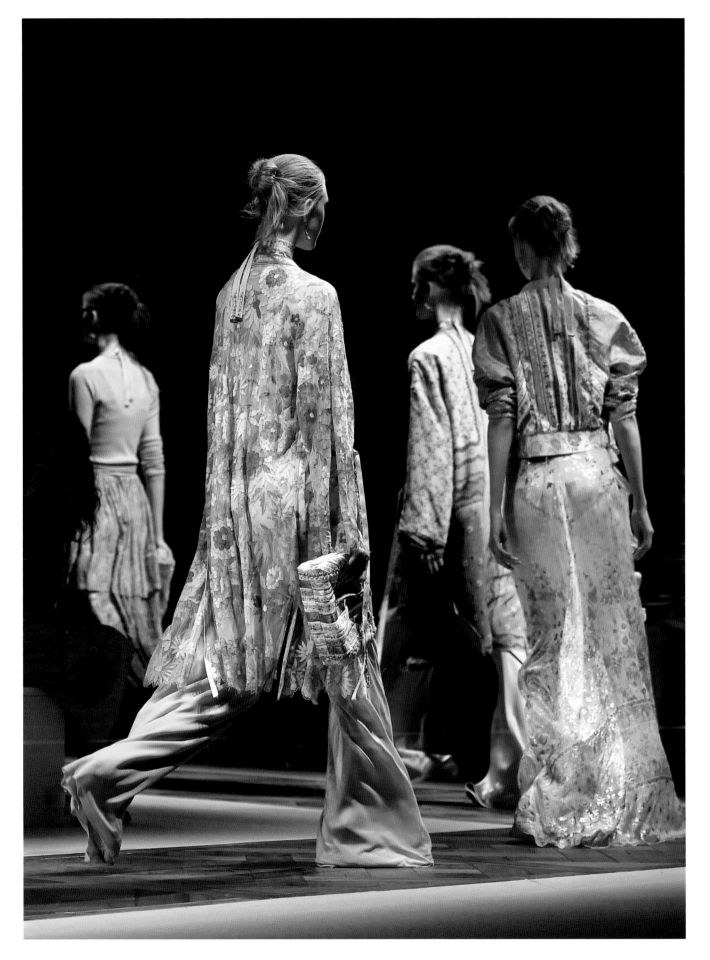

TRENDING

3 To Watch

Vita Kin

42

Vanessa Seward

43

Talitha

44

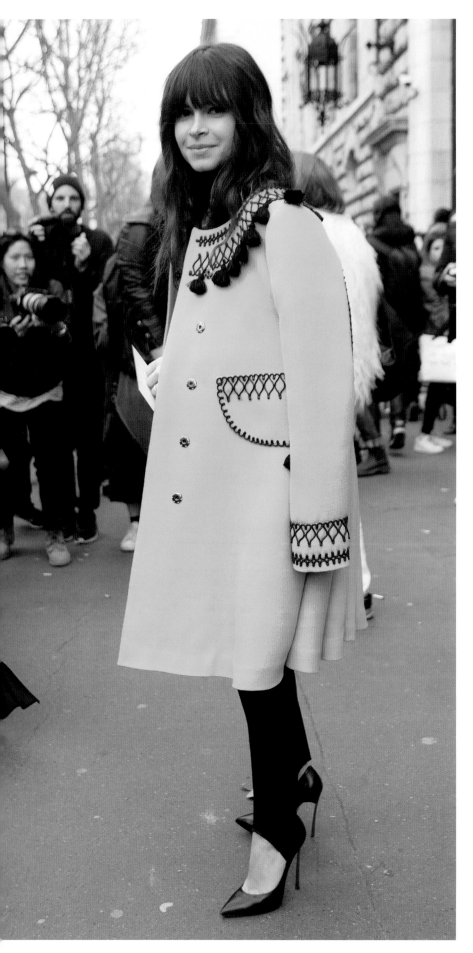

No. 1

VITA KIN

Anyone following street style blogs will find it impossible to miss this Ukrainian designer. Local fashion heroes like Miroslava Duma as well as international style icons Leandra Medine and Anna Dello Russo have posed in the label's embroidered blouses known as vyshyvanka. What prompted Kin to reinterpret her native country's traditional garb as a fashion statement? "The way Ukrainians use embroidery to embellish their clothes has just always impressed me."

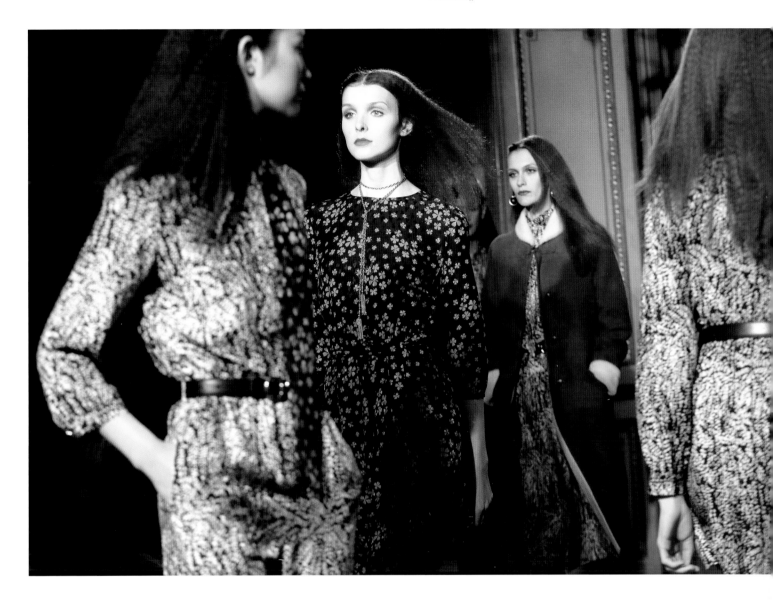

No. 2

VANESSA SEWARD

When the French designer with Argentinian roots, who designed capsule collections for A.P.C. for years, launched her own eponymous collection for the 2015 fall/winter season, one piece became something of a lucky charm: "My clover print midi dress got me a ton of press and sold out immediately." Another bestseller by Vanessa Seward, who admits to a penchant for seventies looks paired with bohemian gold jewelry, to look for: burgundy-colored booties—"as comfortable as sneakers, made with my client, whom I've nicknamed 'the pedestrian,' in mind."

« She is someone who lives the nomadic fantasy and simply wants to weave dreams of Morocco or Tulum into her everyday city lifestyle. »

Kim Hersov

TALITHA

Kim Hersov, founder of Talitha, carries the gypsetting gene in her DNA. Raised in close proximity to hippie haven San Francisco, her childhood role models were Stevie Nicks and Marisa Berenson. Today, the former fashion editor and columnist divides her time between her adopted hometown of London, New York and Capetown. As a result, she looks beyond the flower power era for her holiday collections of embroidered ponchos, floral dresses and floppy hats. Cool girl Kate Moss' holiday wardrobe also serves as a source of inspiration.

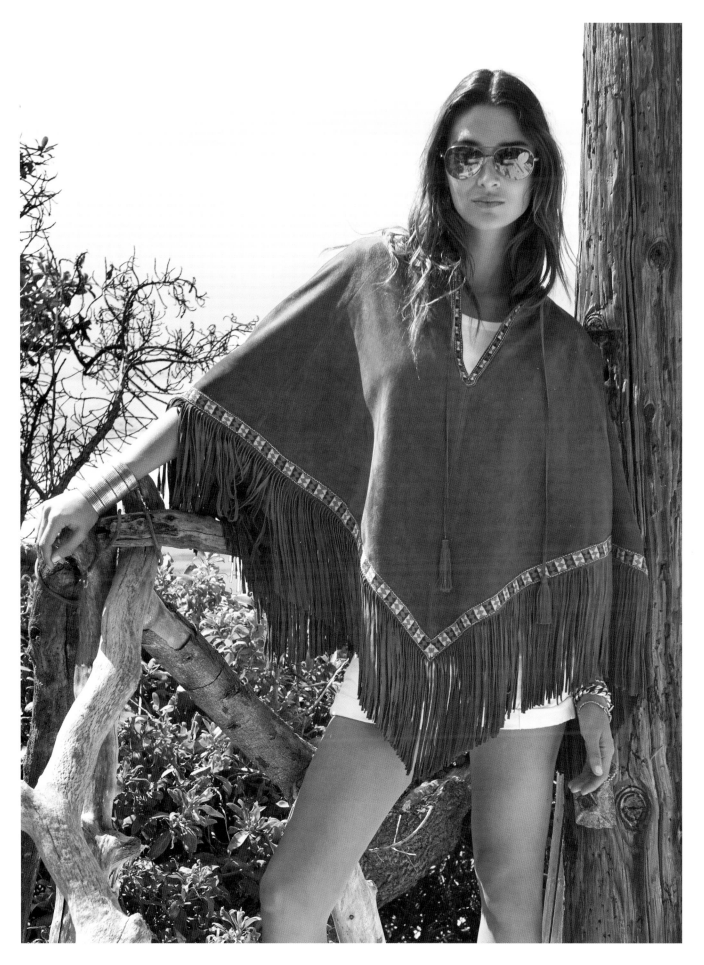

NEVER WITHOUT

by Kim Hersov & Shon Randhawa

Talitha

a hand-embroidered silk cape

embroidered fringed wraps to be worn with leather pants

trans-seasonal suede macramé shawls to be worn with sumptuous silk shirts or peasant blouses

block-printed kaftans on delicate silk-cotton

a block-printed silk dress

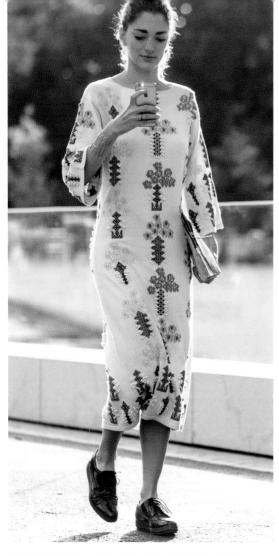

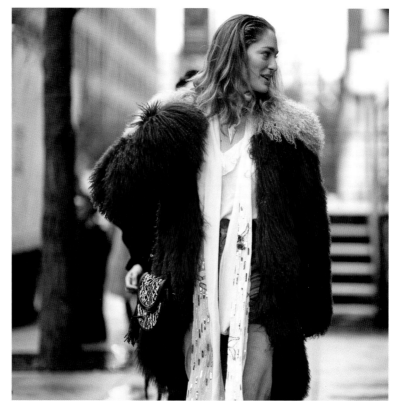

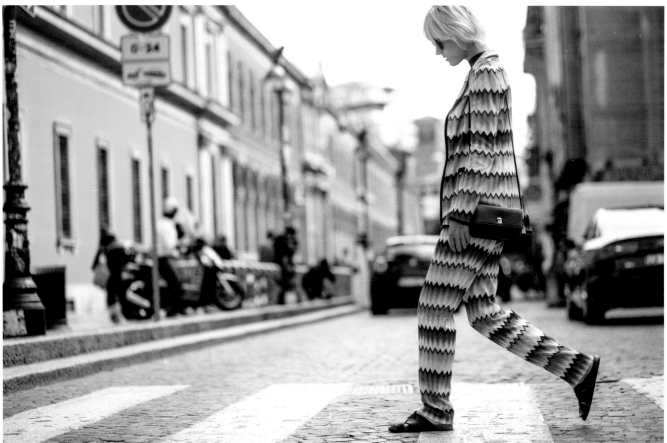

ALL-AMERICAN

L ike most people around the world, I am really inspired by American culture." Not easy to admit for a Brit, one would assume. Yet Stuart Vevers does not seem to agonize over his confession at all. Having been appointed creative director of the long-standing US leather goods brand Coach in 2014, the UK designer has shown his collections in New York ever since. And seems to be having loads of fun with it. At least that's the impression he gives off after his show, set in a space built to resemble the inside of an Ivy League college gym. Baggy eyes, listless answers, vanishing acts after the show? Not with Vevers! He cheerfully shakes hands with five celebrities and explains the inspirations behind his collection to at least twice as many journalists. The funny thing is, when visiting his designer peers backstage—whether we're talking all-American pioneer Tommy Hilfiger or Ralph Lauren, marketing power players Michael Kors or Tory Burch—they're all upbeat. Always.

And honestly, couldn't this relaxed sense of optimism rather than their shared sense of preppy chic aesthetics be the real reason for the success of their all-American looks? Or is it the carefree demeanor of Upper East Side ladies at brunch in their fur coats or dressed in tunics at their Hamptons beach houses; of well-off college kids in polo shirts touring a university campus; or of model icon Gigi Hadid out and about in Midtown New York with her girlfriends wearing a logo sweatshirt? Are we missing anything? "A white shirt," says Tory Burch. Up-and-coming designer Chris Benz, who has been working on a revival of Bill Blass' New York label, agrees and adds his indispensable loafers (for his complete all-American outfit checklist, skip to page 69). And Stuart Vevers, the American by choice? Would add varsity jackets with whimsical patches, worn over western style shirts from his Coach fall/winter 2016 collection. Easy enough!

ESTABLISHMENT

The Big 5

« Our collections are rooted in the American sportswear tradition—versatile pieces that mix classic style with bohemian elegance. »

Tory Burch

TORY BURCH

Romanian peasant blouses, pullovers featuring Moroccan kilim patterns, tunics that instantly transport their wearers to the French Riviera of the sixties: Tory Burch, the seminally successful US designer and reigning queen of the preppy bohemian look, designs dresses like souvenirs—made to be packed into a suitcase and transported from a Caribbean beach getaway straight to a Hamptons sundeck or ski hut in Aspen.

New York, Spring/Summer 2016

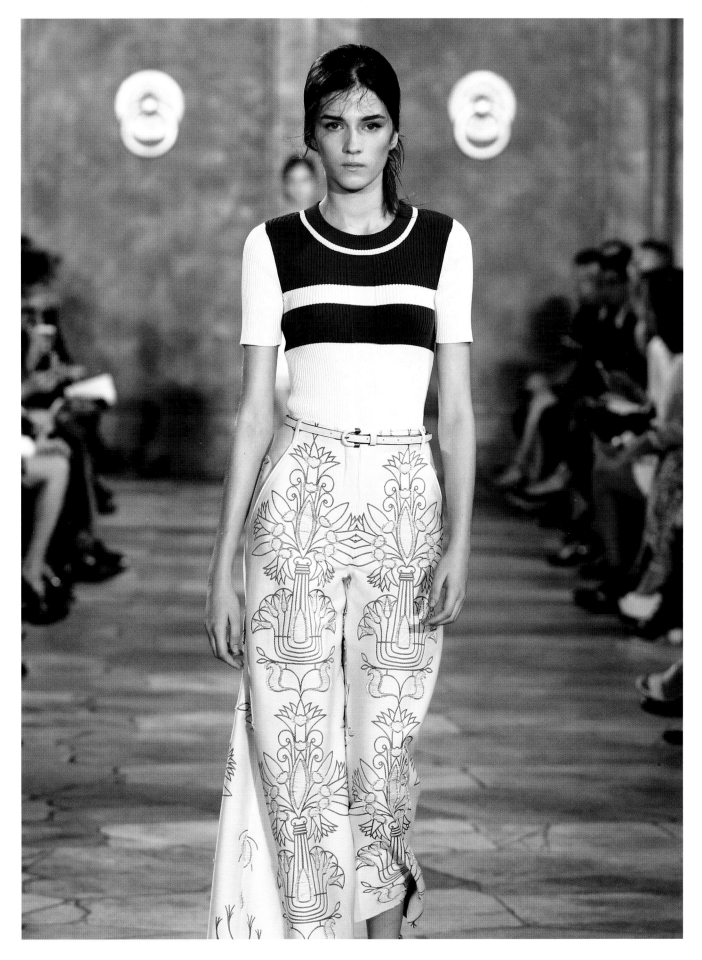

No. 2

RALPH LAUREN

In his career spanning more than 50 years, the grandmaster of the all-American look has transformed his house into a global fashion empire. Born in the Bronx as Ralph Lifshitz, the self-taught designer excels at distilling his fellow Americans' lifestyle into his namesake labels: Polo Ralph Lauren, home of the legendary collar piqué shirt for golf and equestrian enthusiasts, as well as Ralph Lauren Collection serving the lady that, like the designer himself, likes to split her time between Fifth Avenue and her ranch in Colorado.

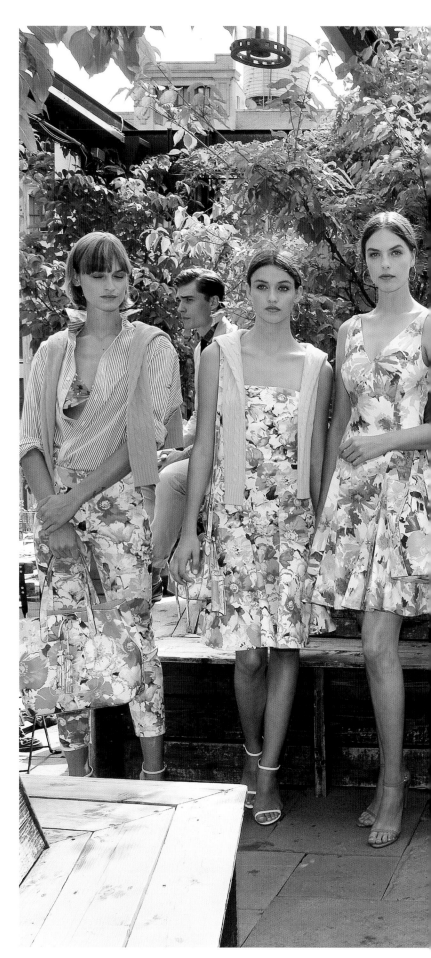

Polo Ralph Lauren, New York, Spring/Summer 2016

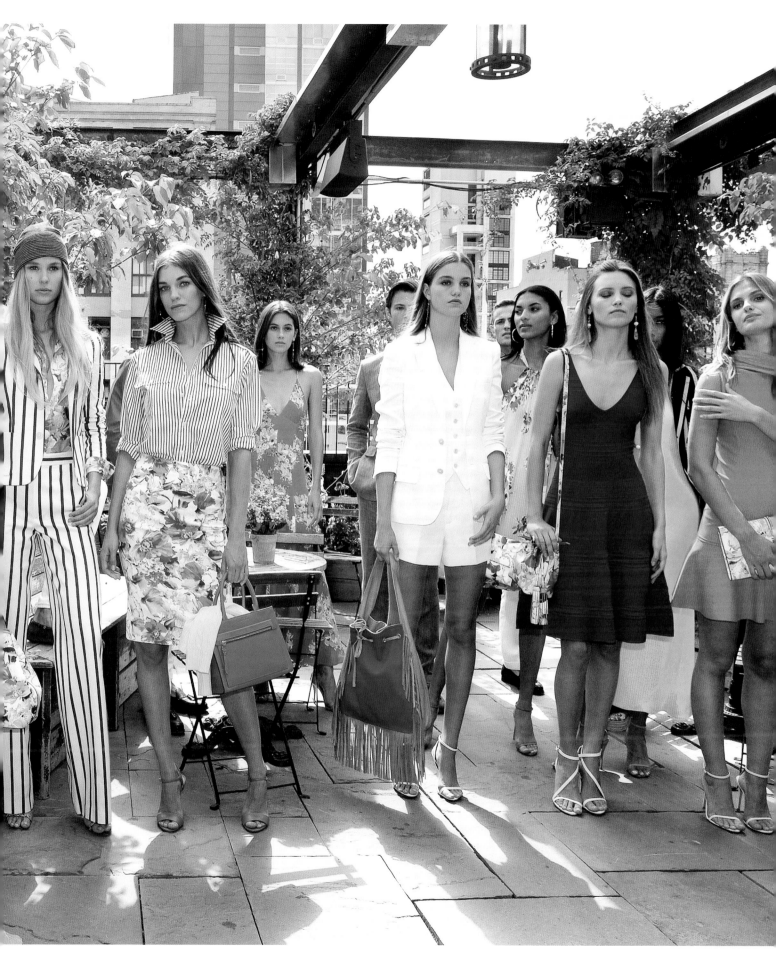

« My inspiration has always remained rooted in classic, all-American style; we celebrate the preppy East Coast lifestyle and we design clothes that are laidback, confident and cool. »

Tommy Hilfiger

TOMMY HILFIGER

Hilfiger has always managed to bridge the gap between high fashion and the commercially successful export of Americana. It comes as no surprise that his runway show usually marks one of the most spectacular events of Fashion Week. Whether it's sand dunes and girls in wetsuits weaving through an obstacle course of surfboards, or models in varsity jackets and sports jerseys marching down an American football field: Tommy is synonymous with the cool casual chic of the East Coast elite anywhere in the world.

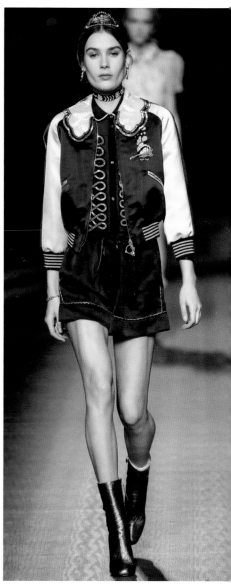

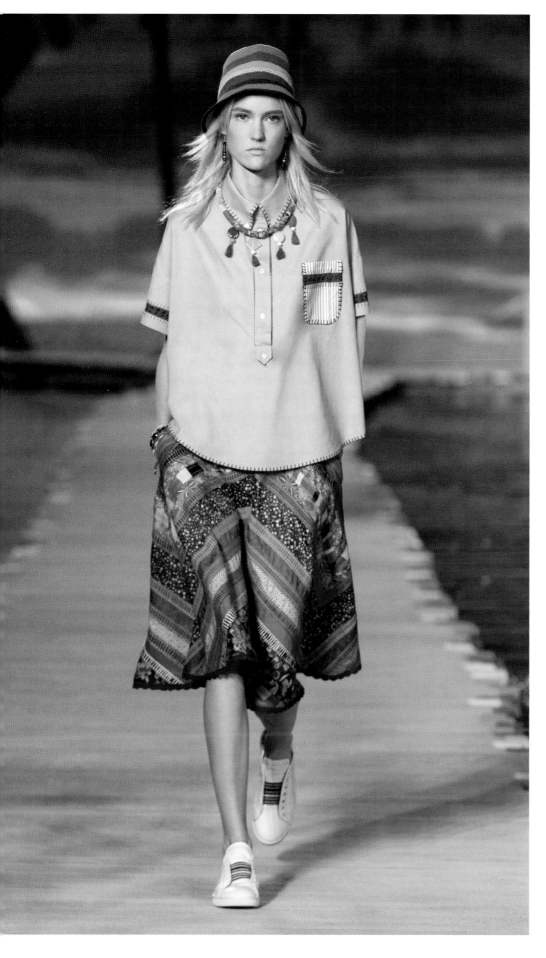

New York,
Spring/Summer 2016 (left),
Fall/Winter 2016/2017 (above)

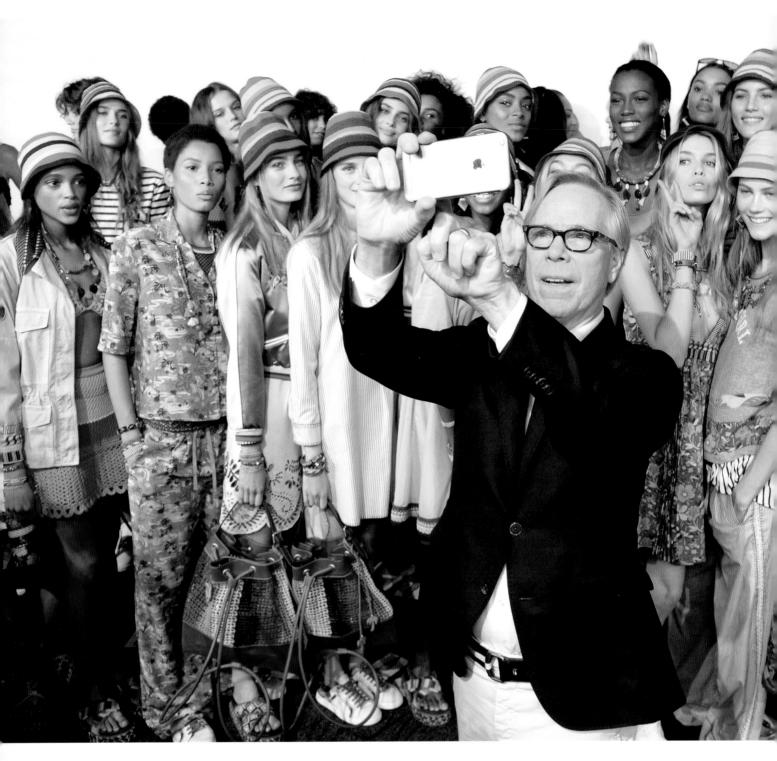

New York, Spring/Summer 2016

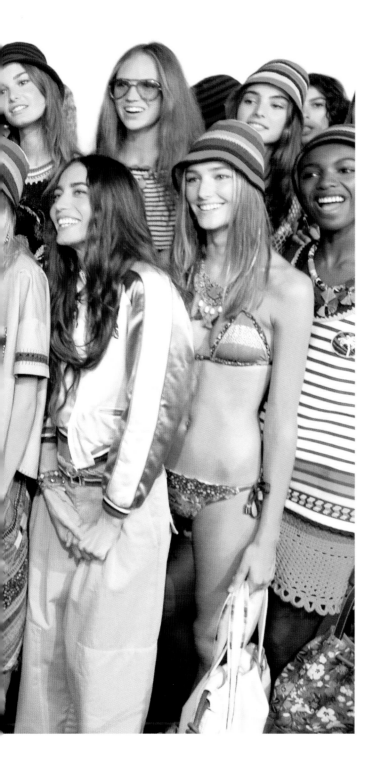

New York,
Spring/Summer 2016

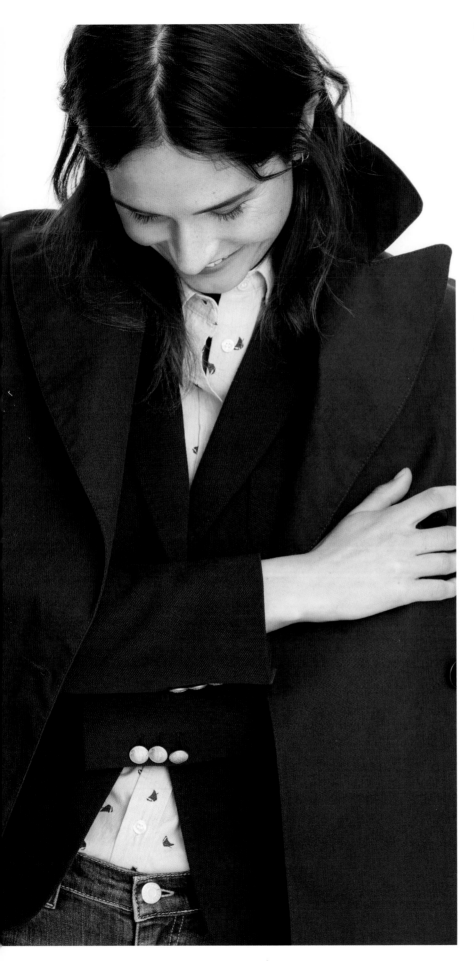

GANT

Gant represents the American Dream like no other. Founded by a Ukrainian immigrant in 1949, the company soon moved to New Haven. Which is where Gant quickly turned into the household label of nearby Yale University, one of the birthplaces of the casually sporty Ivy League look. Although the company headquarters left Connecticut for Sweden long ago, the label's biggest hits are still polo and rugby shirts with that preppy all-American look.

Spring/Summer 2016

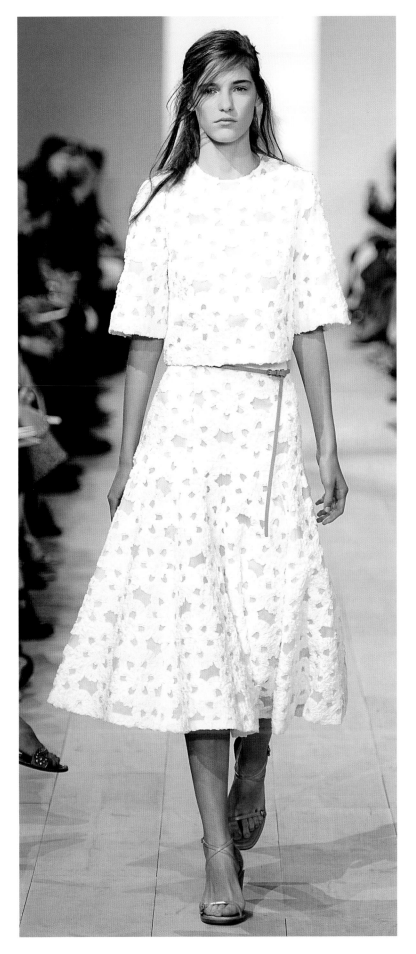

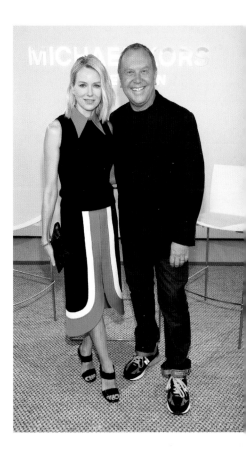

No. 5

MICHAEL KORS

Similar to his all-American peer Tommy Hilfiger, you can't think Fifth Avenue without thinking Michael Kors. Sure, the US lifestyle brand has been enjoying international success—the best-selling bag boasting the MK logo has been a mainstay on pedestrian boulevards around the world—but the look's core is still rooted in a New York state of mind. Each and every season, Kors manages to represent downtown urbanism, uptown glamour and Long Island leisure in his collections.

TRENDING

3 To Watch

No. 1

« Like most people around the world, I am really inspired by American culture.»

Stuart Vevers

COACH

The 75 year old, slightly stuffy US leather brand has, during the last few seasons, undergone a 180 degree turn which is unparalleled in fashion history. Responsible for the feted resuscitation? Former Loewe creative director Stuart Vevers, who in 2014 designed the house's first ready-to-wear collection that had cool girls like Chloé Sevigny instantly lining up. His recipe for success: casual classics (jeans, t-shirts) injected with youthful touches like statement coats and accessories inspired by American iconography.

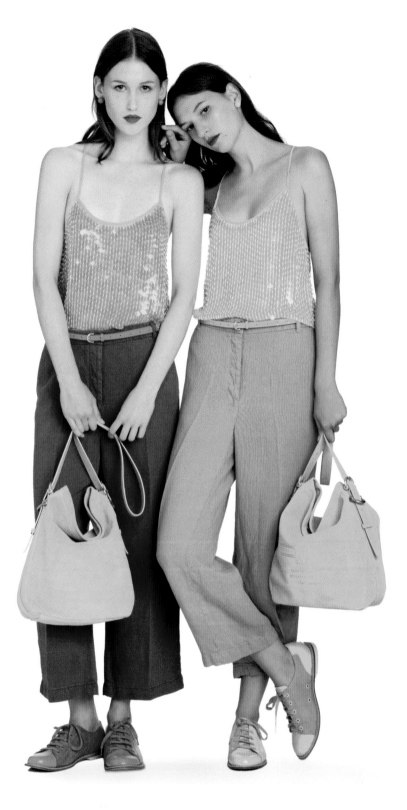

BILL BLASS

After becoming a household name in every American wardrobe since its founding in 1970, Bill Blass disappeared from the fashion radar as soon as its eponymous founder called it quits in the late nineties. 2016 marked the legendary house's comeback. Up-and-coming designer Chris Benz has been reinterpreting the brand's easy glamour. Everyone clear the runway for ruffled skirts, silk blouses, and cashmere sweaters with rugby stripes in pastel Tupperware colors from the label's founding era.

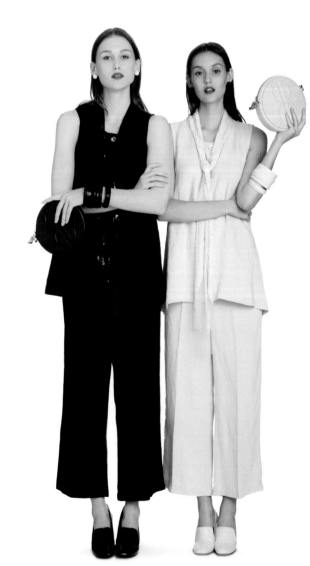

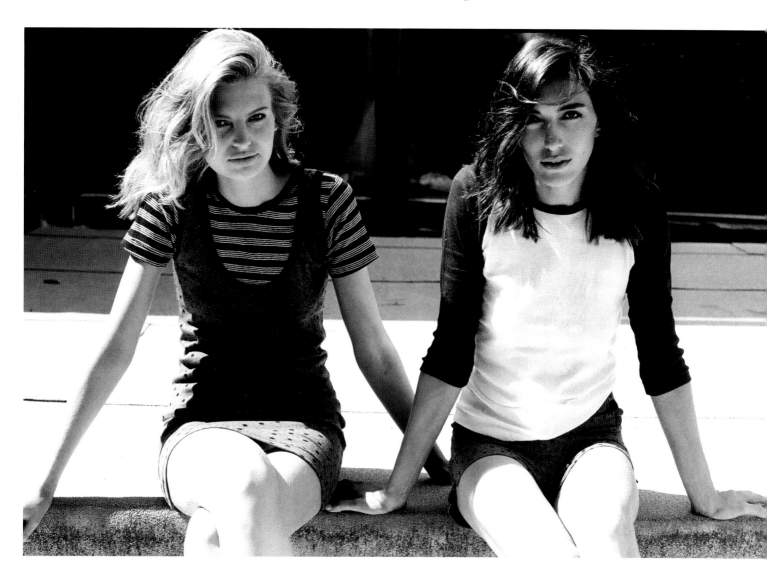

No. 3

EDITH A. MILLER

Once upon a time (in 1920, to be exact), there was a man in Pennsylvania named Robert P. Miller, who made white undershirts. In the nineties, the family business had to be sold off to a bigger company. However, the "Made in the USA" t-shirts survived. A smitten distributor imported them to Japan in 2001, where Humberto Leon stumbled upon them. Having fallen in love with their amazing quality, he bought them for his New York department store Opening Ceremony. Which is where former investment banker Nancy Gibson and designer Jennifer Murray each picked them up. In 2010, they met at a party—both dressed in their Robert P. Miller shirts—and decided to transform the traditional US brand into a contemporary fashion label. New name, new styles (t-shirt dresses, crop tops). An American success story if there ever was one!

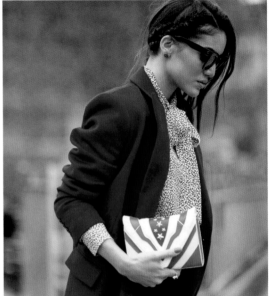

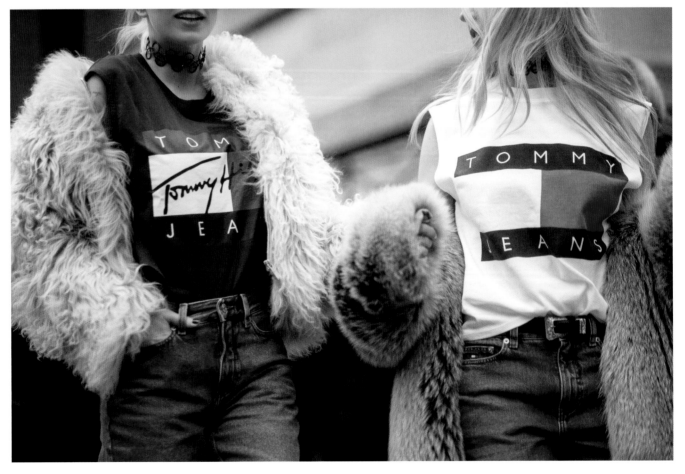

NEVER WITHOUT

by Chris Benz

Bill Blass

a navy blazer

a sequin t-shirt dress

a cashmere cardigan

loafers

a white shirt

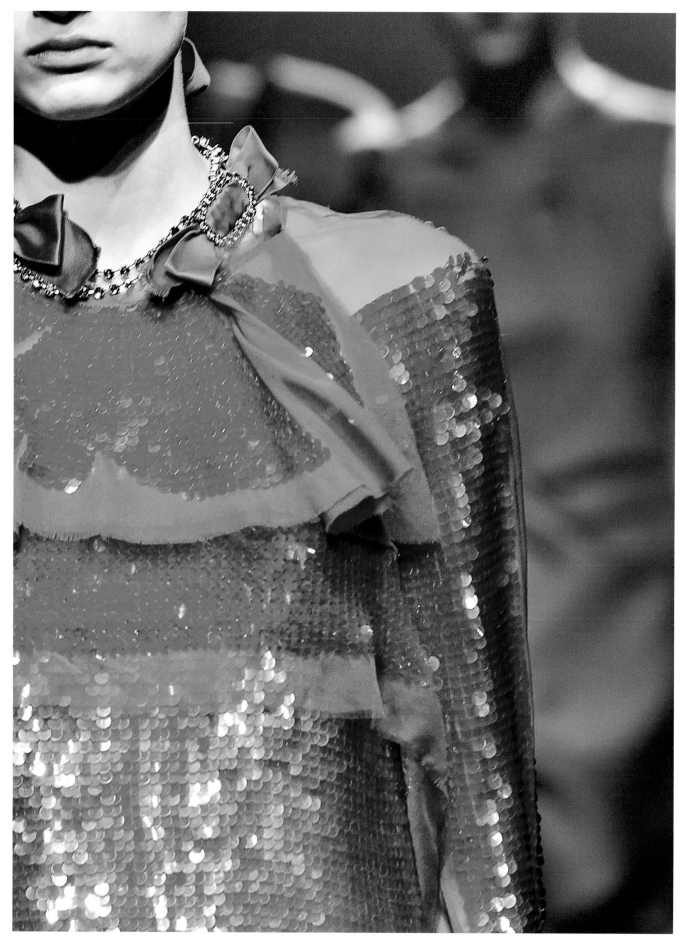

FEMININE & PLAYFUL

Or girls just wanna have fun. If there was room for it on the page, this would have been this chapter's subtitle of choice. Here you'll find everything that girly fashion fans love to have fun with: tongue-in-cheek nerdy chic by Miu Miu and Marni, jewel-toned ruffles and peplums by Lanvin, luxuriously exotic fabrics by Dries Van Noten, and flowing, feminine fantasy gowns by Sarah Burton for Alexander McQueen. What do all fashion protagonists on the following pages have in common? Neither conceptually cerebral dresses, nor fashion minimalism, nor in-your-face sex appeal are their thing. "Fashion is not about power," muses Consuelo Castiglioni of Marni. And Dries Van Noten is aware that "I don't design for myself. I design something keeping in mind that it has to please a lot of women." And the ladies love him for it. "Dries, I Love You," the headline of Leandra Medine's hymn to his block striped pants and vests paired with floral chiffon dresses as well as sequined tops and bustiers for his spring/summer collection 2016, reads. His white flatforms, the perfect juxtaposition to airy summer dresses, received her top marks. Consuelo Castiglioni would have definitely concurred. The designer despises sex appeal—flatforms, the polar opposite of killer heels, are essential parts of her playful, eccentric collections. If it's not about power or sex, then what is fashion all about? "Fashion is joy!" she says. And who in the world has fun with sore feet?

ESTABLISHMENT

The Big 5

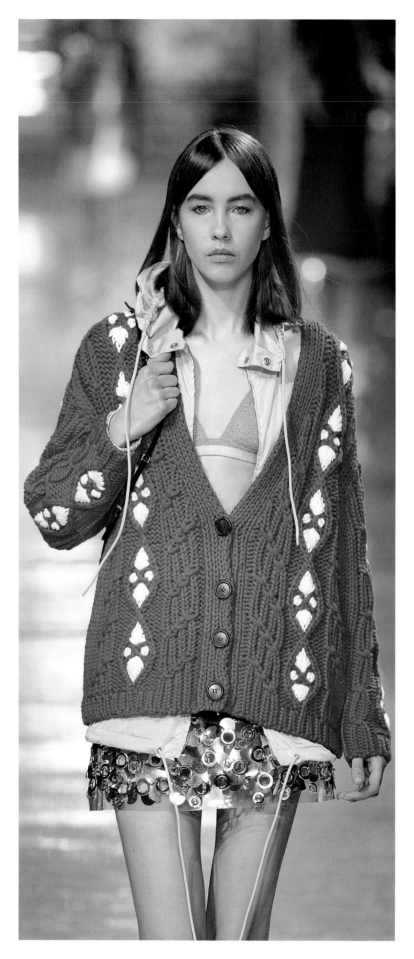

No. 1

MIU MIU

A "creative playground"—that's how Miuccia Prada sees her diffusion line, which she (quite appropriately) lent her childhood nickname. Its motto: irrationality. Its characteristics: crazy layering techniques, featuring tiers of colorful leather, ruffles and gingham check. Accessories (heeled rubber boots, colorful fur stoles) that have the street style set lusting after them each season serve as whimsical cherries on top. Makes sense? Not really! According to Prada, it's not supposed to anyway.

**Paris,
Fall/Winter 2014/2015 (left),
Spring/Summer 2016 (right)**

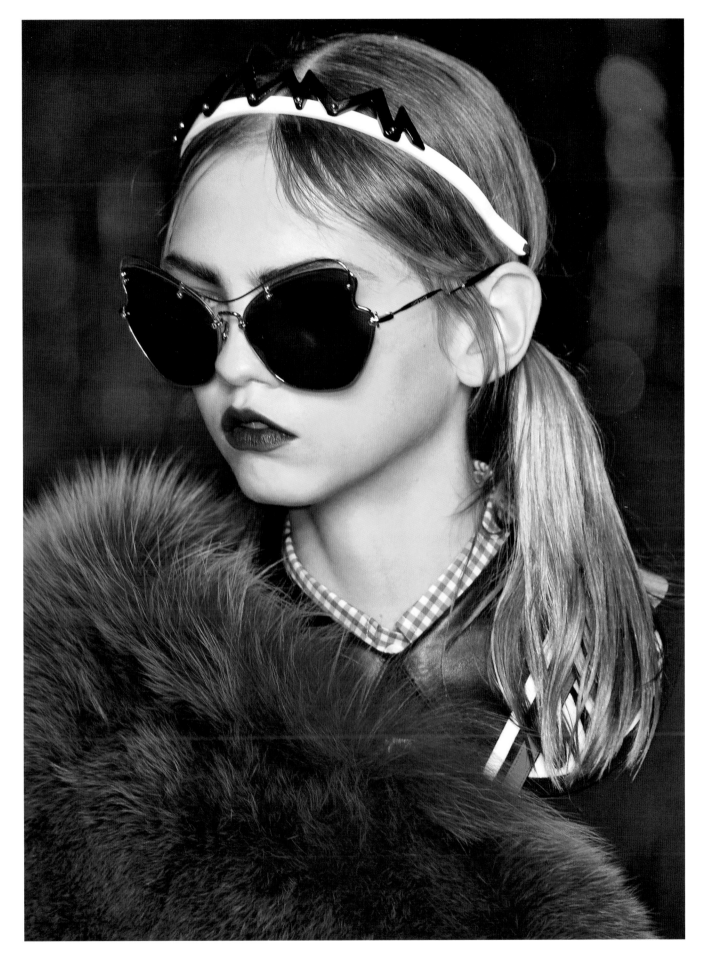

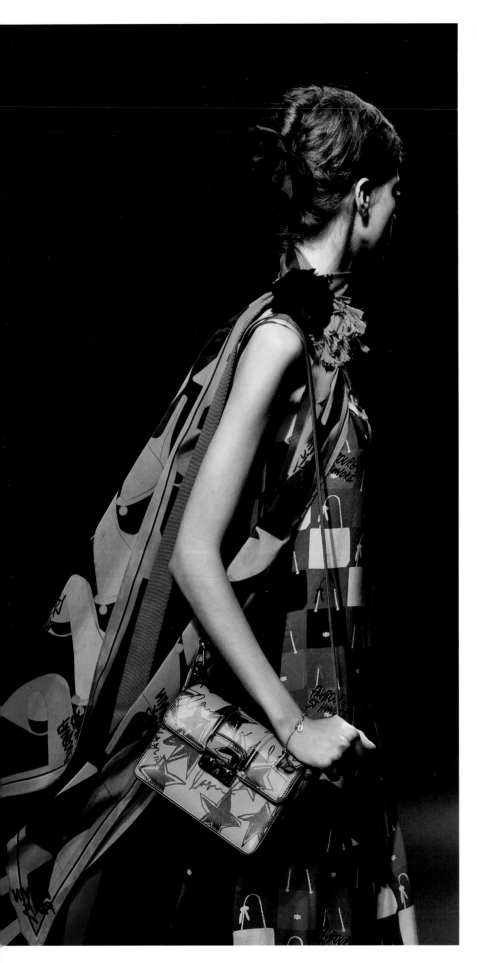

LANVIN

For 14 years, Alber Elbaz made clothes for ladies who love to dress up—but stay grounded at the same time. A self-proclaimed woman's man, the Lanvin creative director liked to steer clear of killer heels and allowed his models in Grecian gowns, playful ruffled mini dresses and jewel colored peplum tops to slip into cool lace-up brogues instead of stilettos. A unique mix of glamour and coolness—and a tough act for Elbaz' successor to follow.

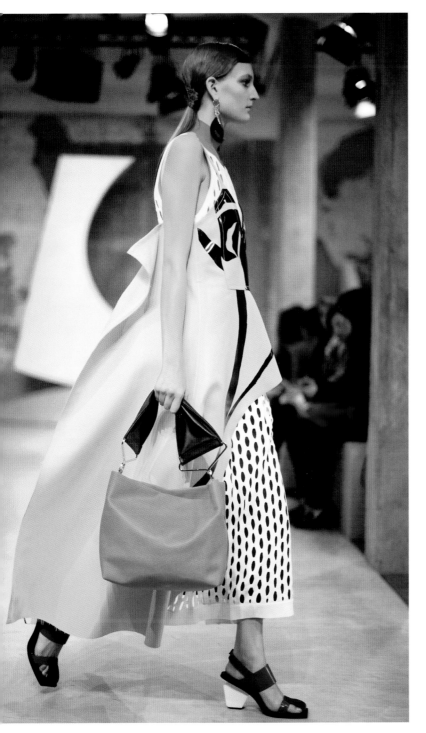

MARNI

Consuelo Castiglioni hates sexy clothes. Instead, she concocts quirky outfits straight out of Wes Anderson's set wardrobe. Asymmetrically draped silk dresses with clashing prints, turtlenecks, chunky neckpieces. And even chunkier sandals. With a nod to German orthopedic footwear, the designer calls them "Fußbett shoes." Whimsical chic, which—cue Marni's successful H&M collaboration—has long broken out of its nerdy niche.

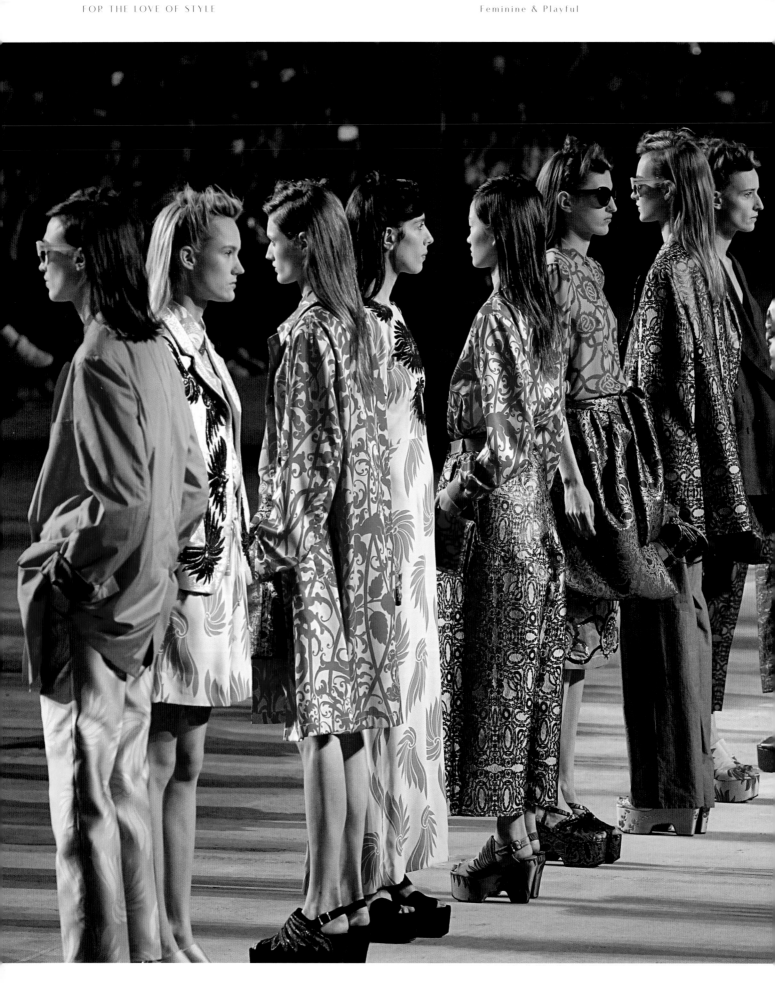

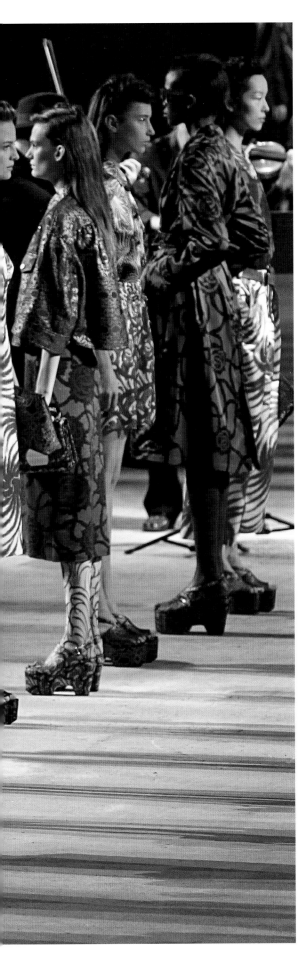

DRIES VAN NOTEN

Eclectic patterns and materials, along with dreamy runway productions—unforgettable: spring/summer 2015's tableau vivant on a bed of moss—make Dries Van Noten's show one of the hottest tickets in Paris every season. That doesn't mean the Belgian's creations (silk kimonos, jacquard jackets and pants with abstract prints and different textures) don't work off the runway—as celebrity fans like Maggie Gyllenhaal, Rihanna, and Michelle Obama, who are frequently spotted in Van Noten, can attest to.

Paris, Spring/Summer 2016

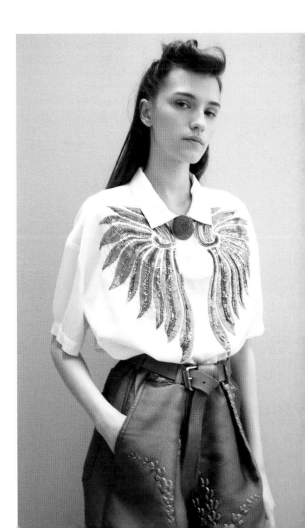

No. 5

«I am a
female designer.
I want to talk
to other women.
I love women.»

Sarah Burton

ALEXANDER McQUEEN

The fashion world has been mourning Alexander "Lee" McQueen since 2010. His collections were provocative, and his shows, which frequently addressed the darkest aspects of our society, legendary. Following the master's suicide, Sarah Burton, who had honed her skills under McQueen for more than a decade, took over. Her move brought a feminine burst of fresh air into the house's upper echelons. It comes as no surprise that her enchanting chiffon creations now dress royals (Kate Middleton's wedding dress), Hollywood nymphs and pop's birds of paradise.

Paris, Fall/Winter 2015/2016

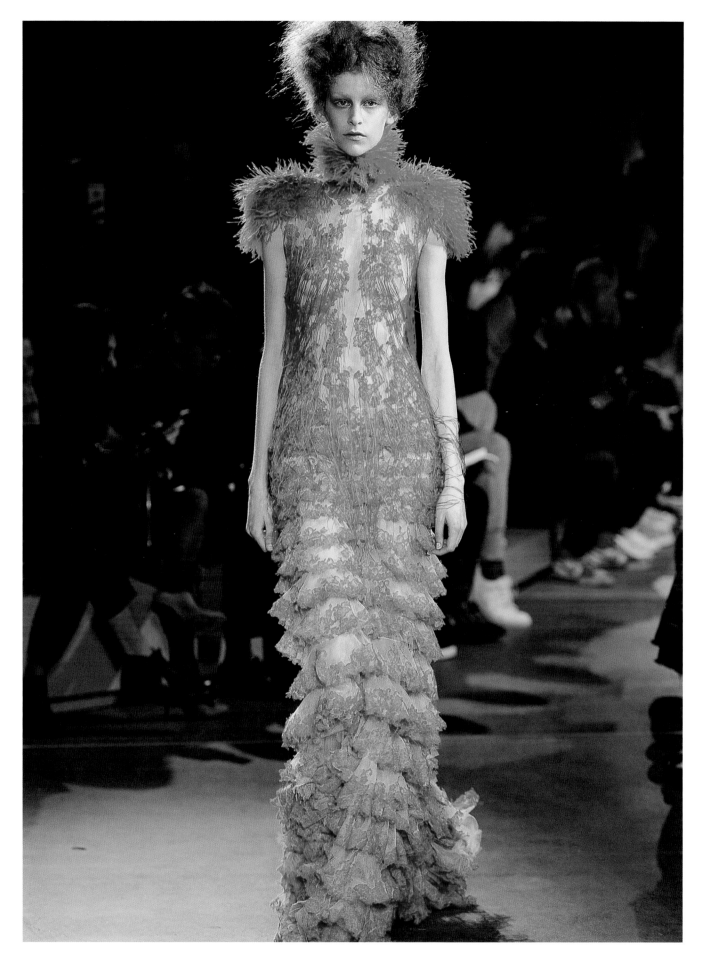

TRENDING

3 To Watch

Simone Rocha

86

Isa Arfen

87

Erdem

88

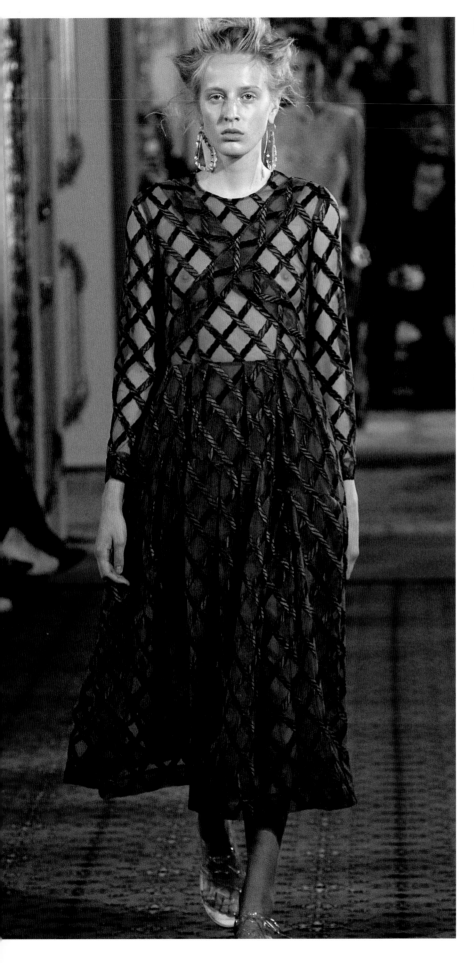

No. 1

SIMONE ROCHA

Translating a tough material like denim into playfully girly dresses takes some serious imagination as well as creative intuition. Simone Rocha has both. For denim label J Brand, the daughter of designer John Rocha created an ultra-feminine jeans collection featuring ruffles, peplums and bows. All little details she likes to add to her ready-to-wear line, which she designs with "a young grungy girl, but also my mum or Patti Smith" in mind.

London, Spring/Summer 2016

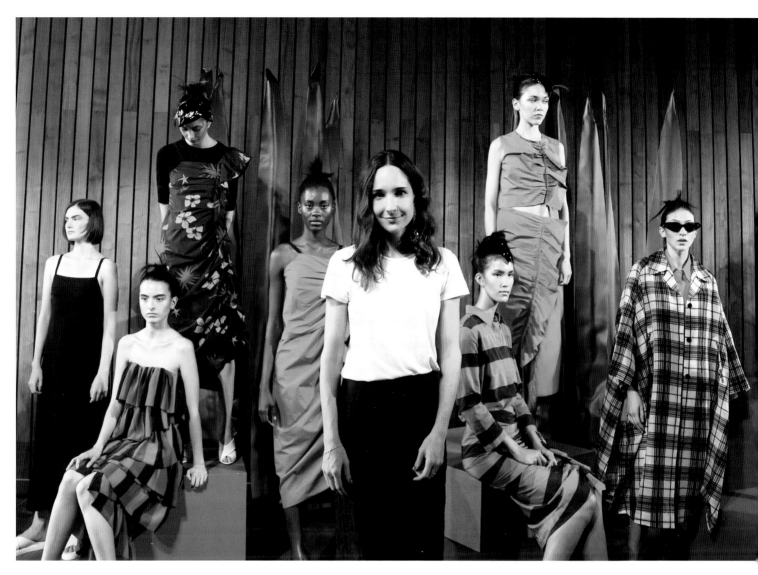

New York, Spring/Summer 2016

No. 2

ISA ARFEN

It should come as no surprise that street style icons like Alexa Chung or "Man Repeller" Leandra Medine, who take a tongue-in-cheek approach to fashion, can't get enough of Serafina Sama's designs. Under the moniker Isa Arfen, the London-based Italian mixes checked a-line coats with cascades of striped ruffles and one-shoulder dresses with neon-colored floral prints. Medine loves her "seemingly reticent sense of sexy that ironically says it all." We agree: How charming!

No. 3

ERDEM

Erdem Moralioglu's forté? Without a doubt, it's what the Brits call tea dresses, which are exactly what they sound like: fluttery, over the knee-length chiffon dresses, high-necked, with ruffly bibs and floral prints. Just what the English gentry would wear for afternoon tea in the Cotswolds. But that's not all: once in a while, the Turkish-born designer teases our sartorial sense with sulphur-yellow lace and cheeky cutouts.

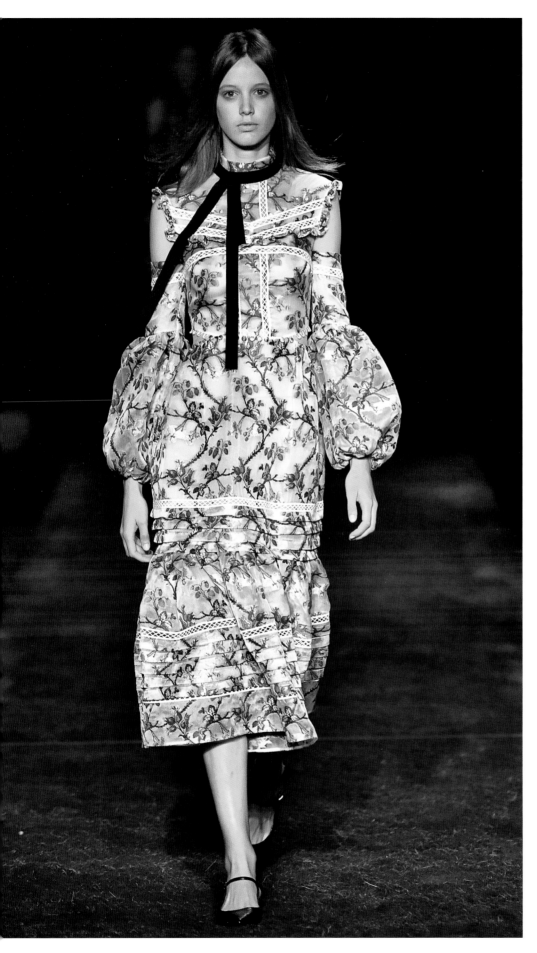

London,
Spring/Summer 2016

NEVER WITHOUT

by Tamu McPherson

All The Pretty Birds

a slip dress

fun sandals with a
block heel

a favorite blouse,
something silky with
ruffles

a good pair of fun
chandelier earrings

cool head gear like a
beret or turban

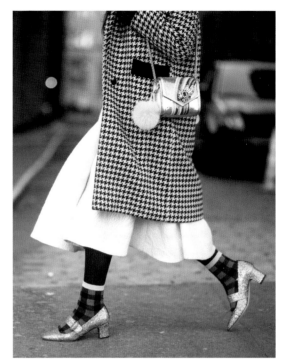

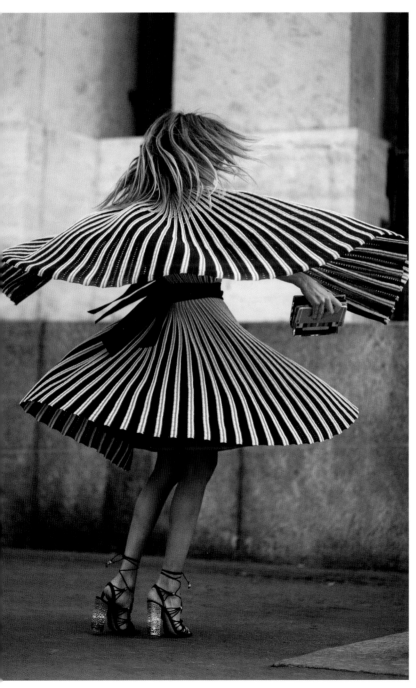

«I think sportswear is now at a point where it is not a passing trend but relevant to our lifestyles.»

Felipe Oliveira Baptista, Lacoste

SPORTY

New York, circa 1985: Hip hop culture, which from the very beginning has adopted the looks of traditional sportswear brands, is on the cusp of infiltrating the mainstream. "My Adidas and me, close as can be," Run DMC rapped until the sportswear company from Herzogenaurach, Germany, became their official sponsor. Cool kids in the streets were suddenly wearing clothes that used to be stuffed into gym bags. US designers Ralph Lauren, Calvin Klein and Tommy Hilfiger caught wind of this trend and created their own XL sweatshirts bearing their company logos.

Fast forward: "Yesterday's sportswear is making a huge comeback," enthuses Felipe Oliveira Baptista, child of the nineties and current creative director at pioneering polo shirt label Lacoste. "But it's not just a passing trend this time. Sports play a much bigger role in our lives today.

And I guess we are also looking for simplicity in every other aspect. No wonder we're seeing people wearing suits with their Nike sneakers again." Even Calvin's and Tommy's sporty cult collections from back in the day have returned to the shelves. Their logos—combined with skater beanies or baseball caps and Stan Smiths by Adidas—have become a ubiquitous sight in every fashion week front row. At the same time, sportswear has also conquered the runways—especially in New York. DKNY, Alexander Wang and Vetements have all hopped aboard the logo mania train with their printed sweatshirts and hats. Newcomers like Public School and Off-White have dedicated themselves to churning out luxuriously sporty chic. So what about today's hip hop icons? Kanye West and Rihanna (for Puma) have, of course, taken to designing hoodies and jogging pants of their own.

ESTABLISHMENT

The Big 5

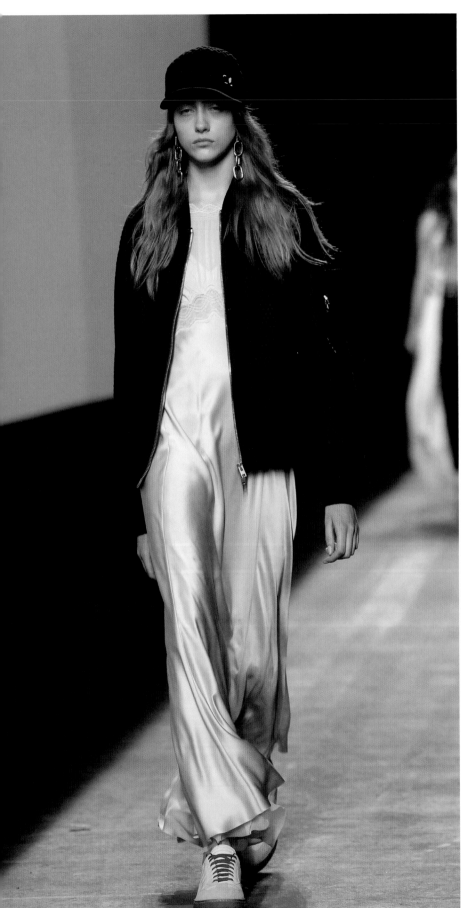

ALEXANDER WANG

No one does coolness quite like Wang. His commercially successful interpretation of downtown Manhattan street style helped the New York designer tailor his way to creative director at Balenciaga, the Paris house he ended up spending only six seasons with before calling it quits. Wang went back to what he knows best: t-shirts, hoodies, leather shorts and mesh mini dresses. His loyal followers (models Hanne Gaby Odiele and Binx Walton, rappers A$AP Rocky and Nicki Minaj) will be the first to give him props.

New York, Spring/Summer 2016

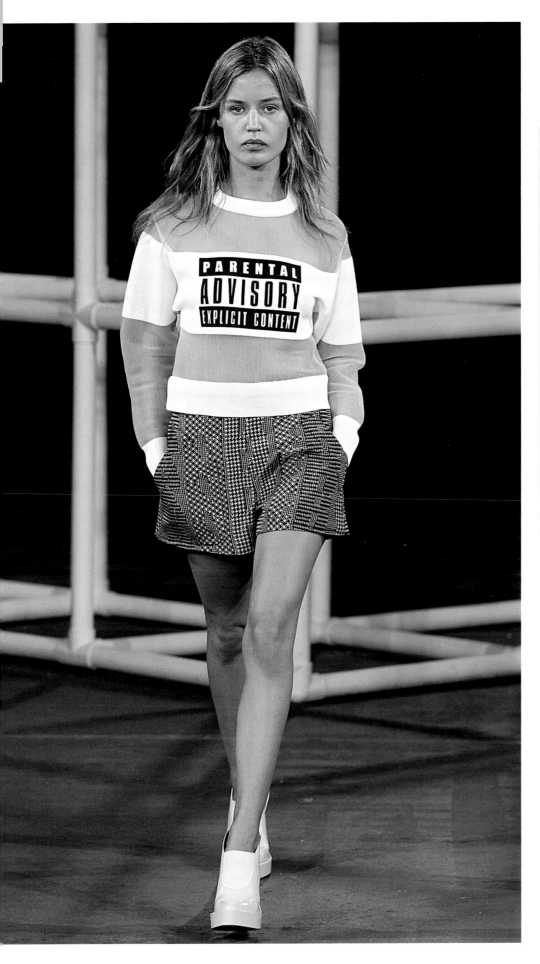

New York,
Spring/Summer 2014

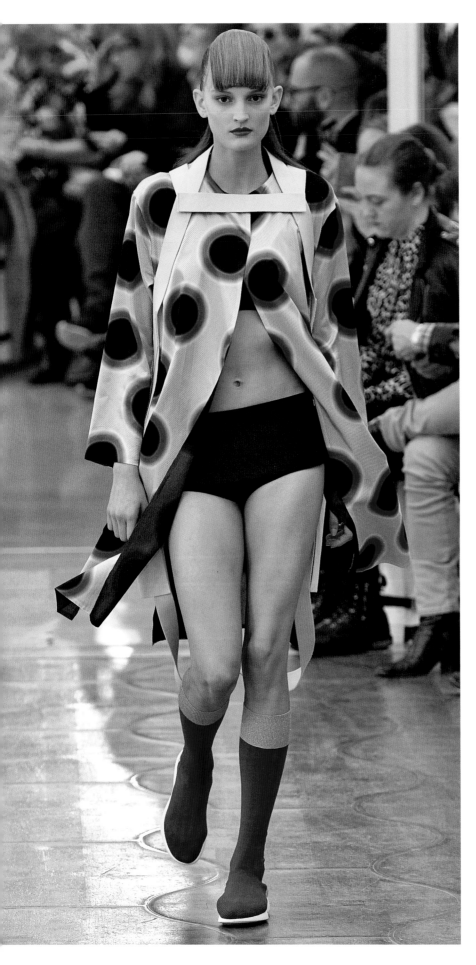

ACNE STUDIOS

Anyone who has ever been to Stockholm knows that streetstyle savvy is not the exclusive domain of New York, Paris and Milan. Street shots from the Swedish city helped propel "Scandi style"— and local labels—into the international fashion limelight. Stellar example: Acne. What started out as a creative collective morphed into a cult denim brand and was later reborn as ready-to-wear label Acne Studios, now featuring—in addition to their signature skinny jeans—the coolest XL shearling biker jackets, leather boots, sweatshirts and t-shirt dresses.

DKNY

"Like caviar and pizza." That's how Donna Karan described the difference between her collection line and DKNY, her sartorial well of laid-back basics for young New Yorkers. Thanks to Dao-Yi Chow and Maxwell Osborne, heads of the much-hyped label Public School (pp. 106/107), that well won't dry up anytime soon. As the label's new creative directors, they continue to champion sporty chic looks with New York as their muse. Joining their t-shirts and sneakers, though, will be grown-up reinterpretations of DKNY classics (Hello again, pinstripe power suit!) of yore.

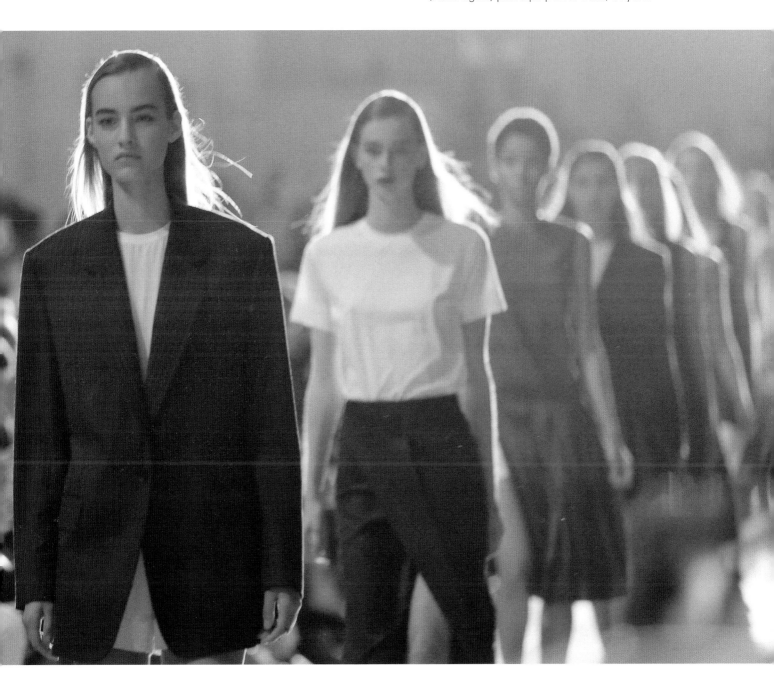

No. 4

LACOSTE

One of the biggest recent trends is "athleisure," describing outfits made to work on the cross trainer and/or lunches out with friends. It's a concept that, God knows, is no novelty: Over 80 years ago, tennis champ René Lacoste created shirts that could be worn from the court straight to the café—paving the way for designer Felipe Oliveira Baptista, who mixes the French brand with the crocodile's sporty separates (tracksuits, polo shirts) with urban details like perfectly tailored coats.

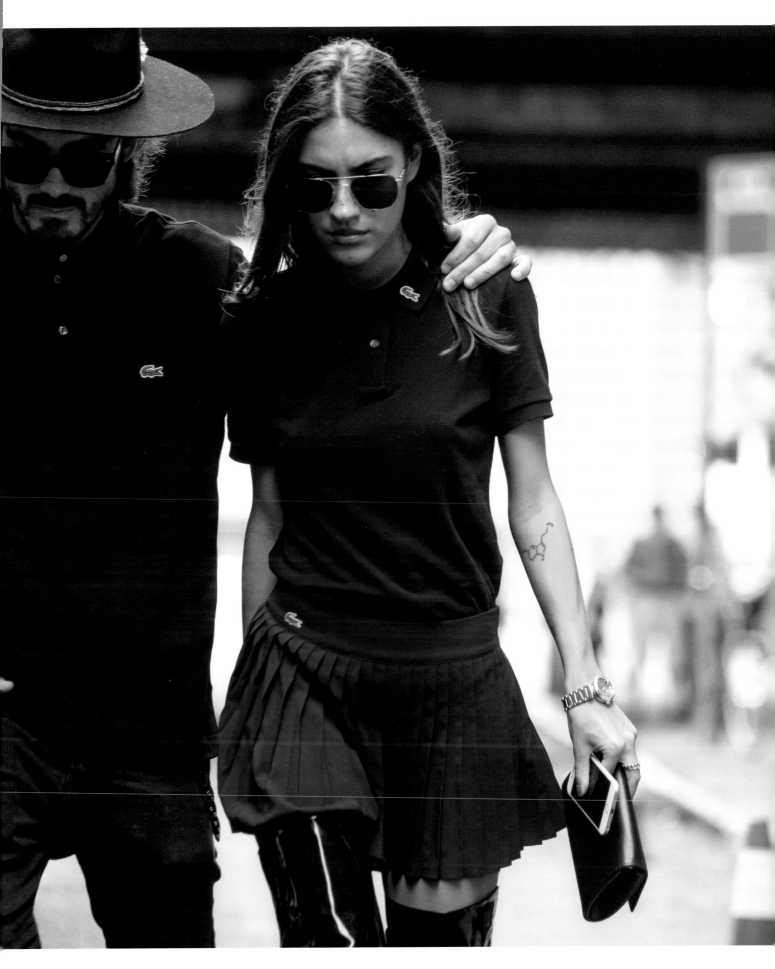

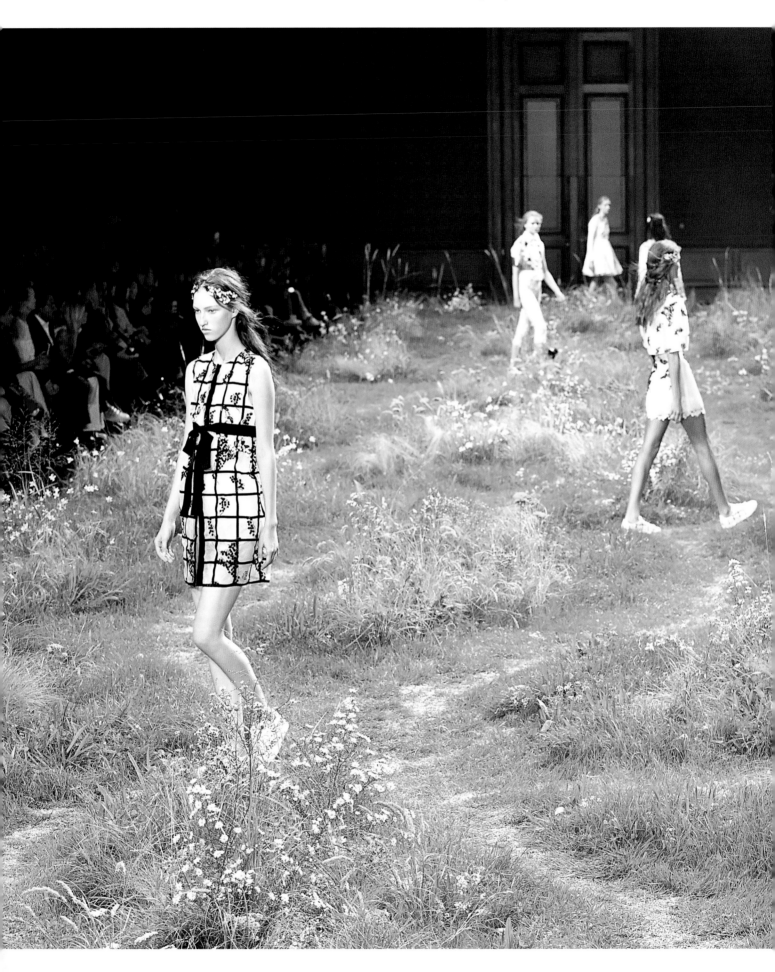

No. 5

MONCLER

Could the Italian outerwear label have scored any more street cred than with the much debated and even more frequently spoofed video for "Hotline Bling" that has rapper Drake gyrating his hips while sporting a red down jacket by Moncler? Hardly! That being said, the cult label's so-called puffers have never suffered from a lack of coolness. In the olden days, Jackie Kennedy and Brigitte Bardot wore them on the slopes; today, Beyoncé likes to take them out on the wintery streets of New York.

Paris, Spring/Summer 2016

TRENDING

4 To Watch

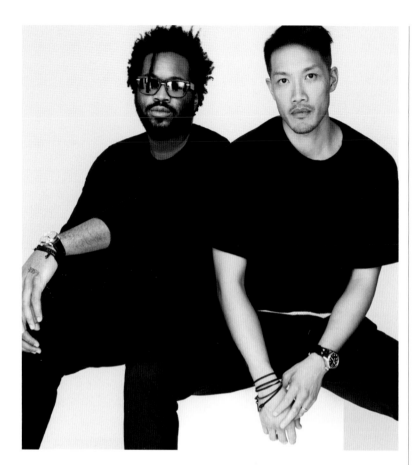

PUBLIC SCHOOL

Everyone who happens to bump into Dao-Yi Chow and Maxwell Osborne on the New York nightlife circuit inevitably leaves the club with the same thought: How cool are these guys? Sporting t-shirts, black jeans and Nike sneakers, they look exactly the way every New Yorker wants to feel: easy-going. Good thing their young label is a playbook of exactly that type of fashionable effortlessness: jeans, t-shirts, hoodies and track pants, baggy shorts and boxy blazers. For boys or girls? Doesn't really matter! In the end we all want to look this carefree.

New York, Spring/Summer 2016

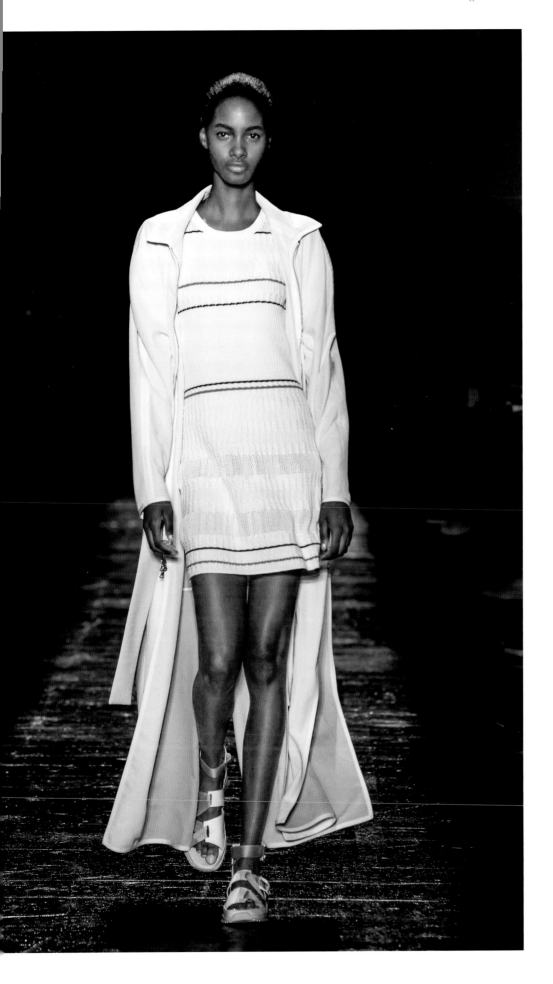

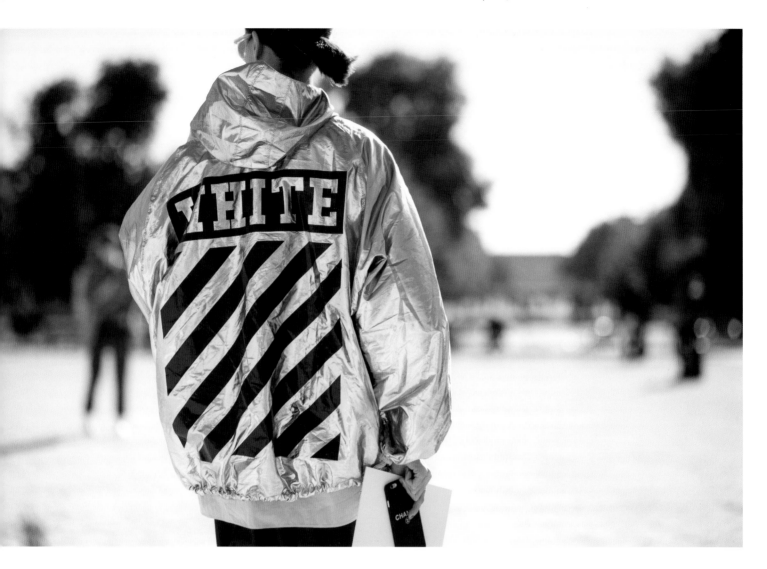

No. 2

OFF-WHITE

As the creative director to self-proclaimed best-dressed rapper Kanye West, Virgil Abloh has been responsible for shaping the rap scene's aesthetic for years. The t-shirts he initially had custom-printed for a circle of close friends garnered exceptional press in no time. No wonder, given that these friends go by such illustrious names as Rihanna and Jay Z. It didn't take much more for Abloh to launch his own label. Today, he creates "sophisticated streetwear" in his Milan studio that continues to evolve from the t-shirts and army jackets he started with.

No. 3

VETEMENTS

Out of nowhere, this label by the design collective headed by Demna Gvasalia managed to become the talk of the fashion world within three seasons. How? With outfits the designer seems to have picked up on the L Train to Brooklyn or in Berlin's Berghain: neon miniskirts, XL raver pants, sweatshirts with extra-long sleeves paired with bright logo overknees, high-waisted mom jeans. Different—but wearable. The clothes had critics and fashion fans raving. Then Balenciaga came knocking at the door. And guess what? Gvasalia was appointed creative director of the Paris fashion house.

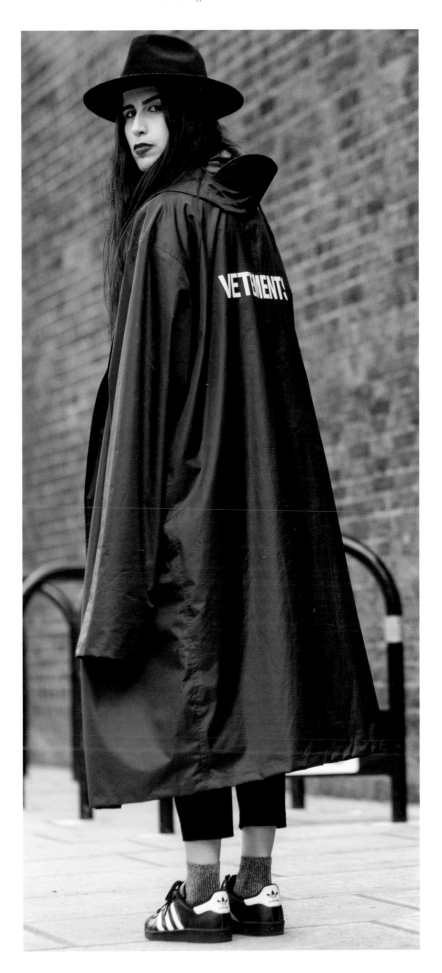

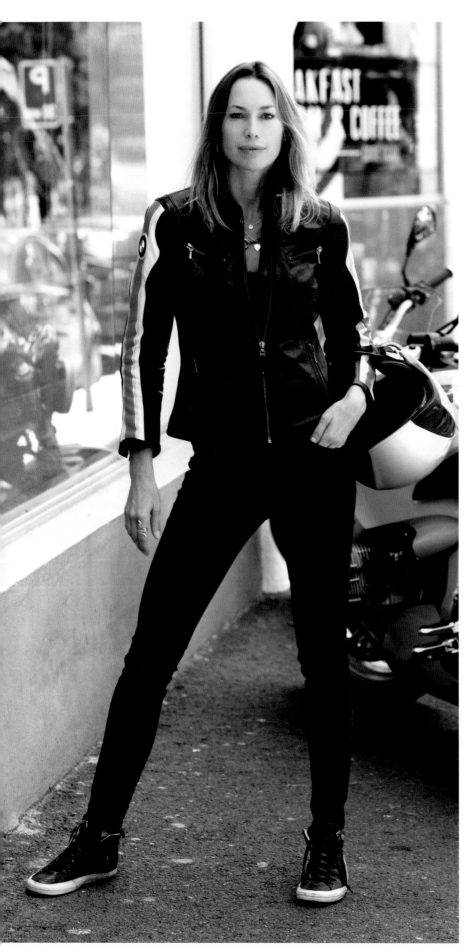

BMW MOTORRAD

Riding a motorcycle has always been associated with freedom, independence, and adventure...but not so much with adventurous fashion. Only the motorcycles themselves are truly chic and hip—the outfit is strictly functional. But BMW Motorrad has decided to change all that! You can slip into form-fitting, stylish leather jackets, jeans, shirts, and everything that makes your heart race. Now everyone can look great on a motorcycle—or just standing next to one, true to our motto: Make Life a Ride!

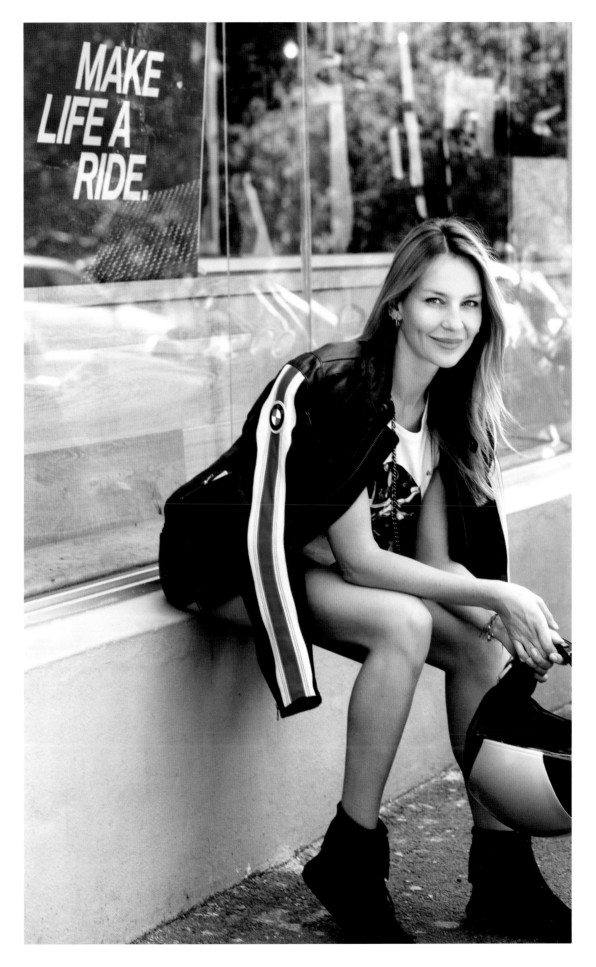

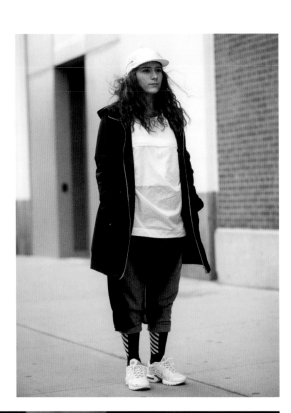

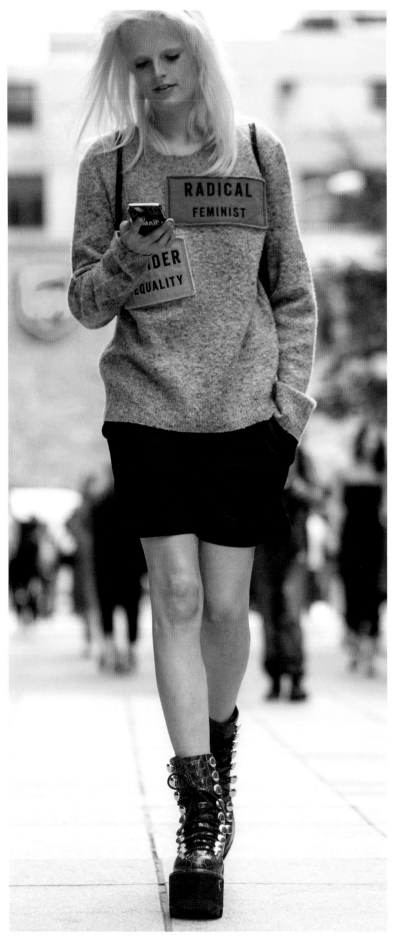

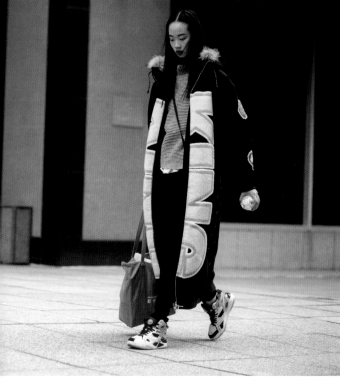

NEVER WITHOUT

by Felipe Oliveira Baptista

Lacoste

a polo shirt

a mac

a chic version of
track pants

a great pullover

a good pair of sneakers,
of course

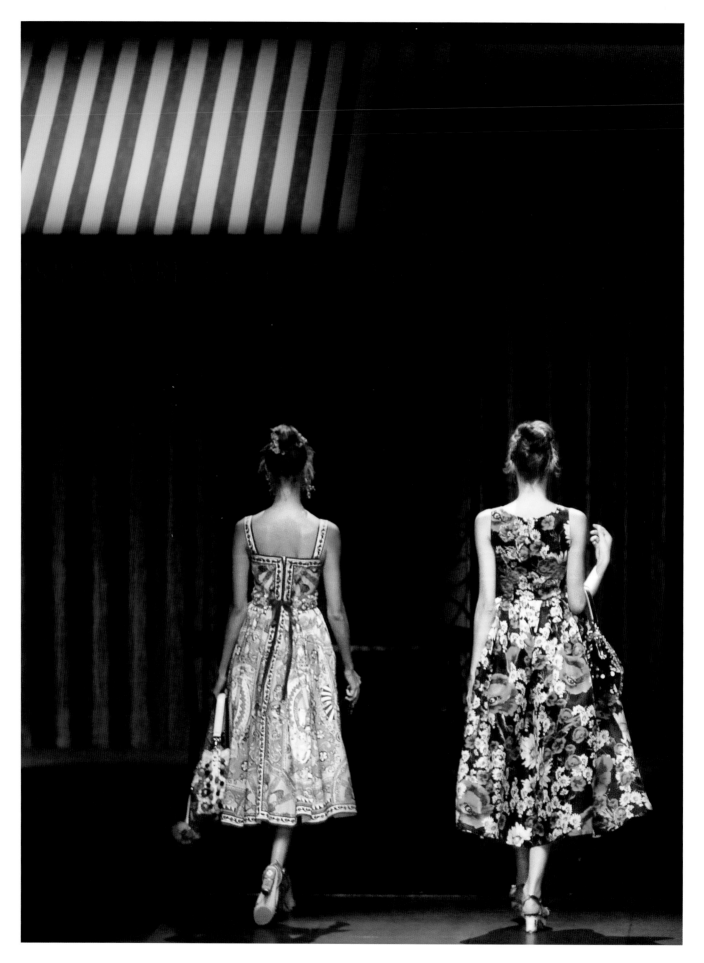

ITALIANS DO IT BETTER

talian fashion is not about innovation. It has no desire to offend, provoke or mislead, surprise us with avant-garde cuts, or blur gender lines. Instead, it likes to follow traditional ideals of beauty and role models and stick to harmonious color schemes. And of course, it has to be "Made in Italy." When asked about her wardrobe essentials, even Stella Jean, who belongs to a new wave of young designers shaking up the uniform looks on the streets of Milan, Rome and Florence with crazy pattern plays and a knack for internationally acknowledged sex appeal, reverts to the good old classics. Even Massimo Giorgetti of contemporary Italian label MSGM fame explained to *New York Magazine* that "We don't do any of that 'witchcraft' fashion with all the weird extras and strange straps and huge sleeves." Boring, you may say. And wonder why we felt the Italians deserved an entire chapter, which we, on top of everything else, audaciously titled 'Italians Do It Better.' Well, they do. Because the way to read our tongue-in-cheek title reflects the way we feel Italian fashion should be viewed: seldom trailblazing, but with the occasional sophisticated surprise (Prada) or iconoclast (Alessandro Michele at Gucci) in store. Plus, the charming homages to Bella Italia presented each season by Dolce & Gabbana, Pucci and Cavalli could fill volumes. Speaking of filling: If you'd rather fill your closet, consider starting with Stella Jean's classics and heirlooms (on pages 136/137). And maybe build up to a wildly patterned sweater from the MSGM collection.

ESTABLISHMENT

The Big 5

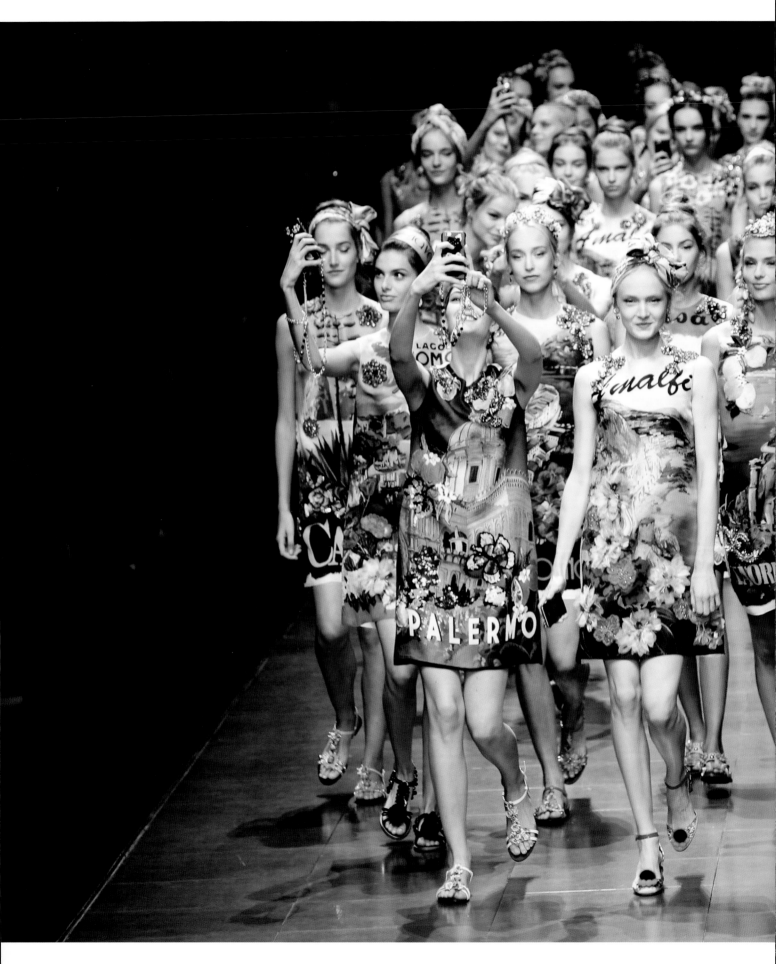

No. 1

DOLCE & GABBANA

As soon as Stefano Gabbana and Domenico Dolce send out invites to their show in Milan, Italy's tourism board can close up shop. With collection themes like Viva la Mamma or Sicily, the designer duo transforms dolce vita into textiles. Their spring/summer 2016 motto: Italia is Love! It's a beautifully literal homage to their native country that no copywriter could have improved on, let alone executed more charmingly: as an embroidered statement—next to a Venetian gondola—on a citrus shift dress.

Milan, Spring/Summer 2016

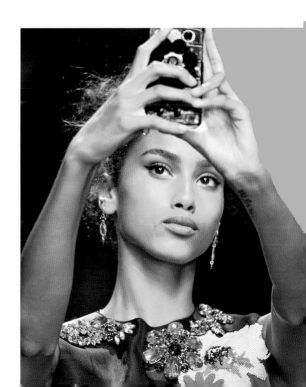

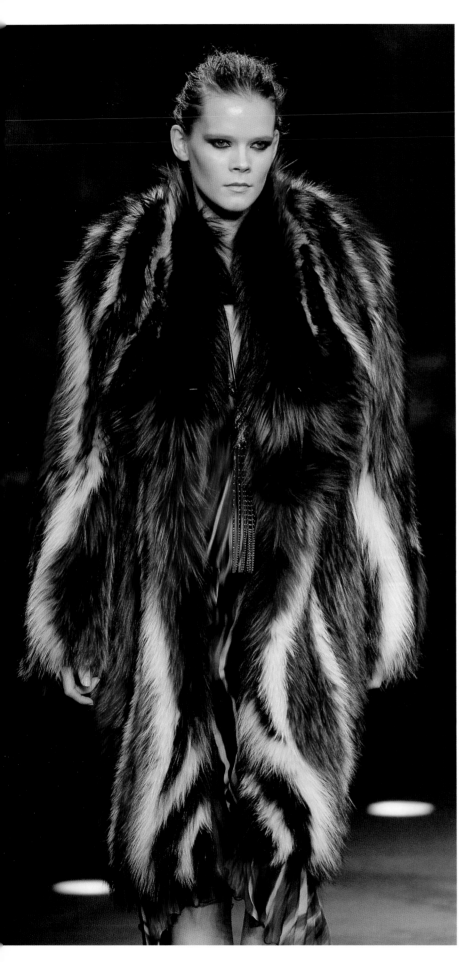

ROBERTO CAVALLI

"Excess is my success!" No one could have
summed up the Cavalli formula better than the
Florentine designer himself. There's reptile
leather, fur, studs, metallic, animal printed leather,
denim, and chiffon. More is more! But wait...
fabric might be the only thing allowed to literally
come up short chez Cavalli—as long as it reveals
deep cleavage, legs for days, and trim waists.
Sex on a platter, which—with an added pinch of
rock'n'roll—is exactly what former Pucci designer
Peter Dundas has been serving up at the label
since spring/summer 2016.

No. 3

PUCCI

Prints, prints, Pucci… Having Massimo Giorgetti, founder of rookie label MSGM known for crazy pattern plays (pp. 134/135), take over as creative director of Pucci was a no-brainer. The Italian brand has been famous for its glamorously patterned jet-set garb since the sixties. Peter Dundas transported it to Ibiza with his sexy luxury hippie looks (cue chiffon slips with lace-up ties across navel-deep cleavage). And just in time for the Instagram generation, his successor Giorgetti has been taking it back to the block with his streetstyle-worthy pieces.

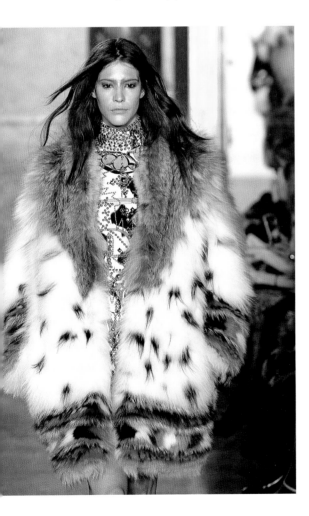

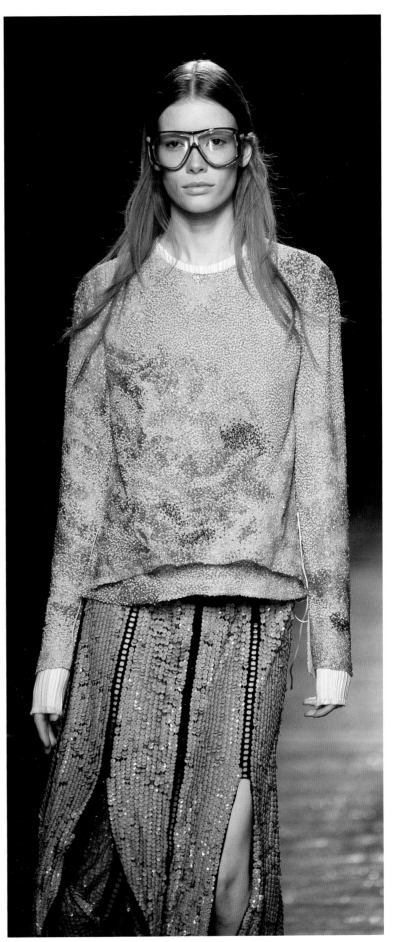

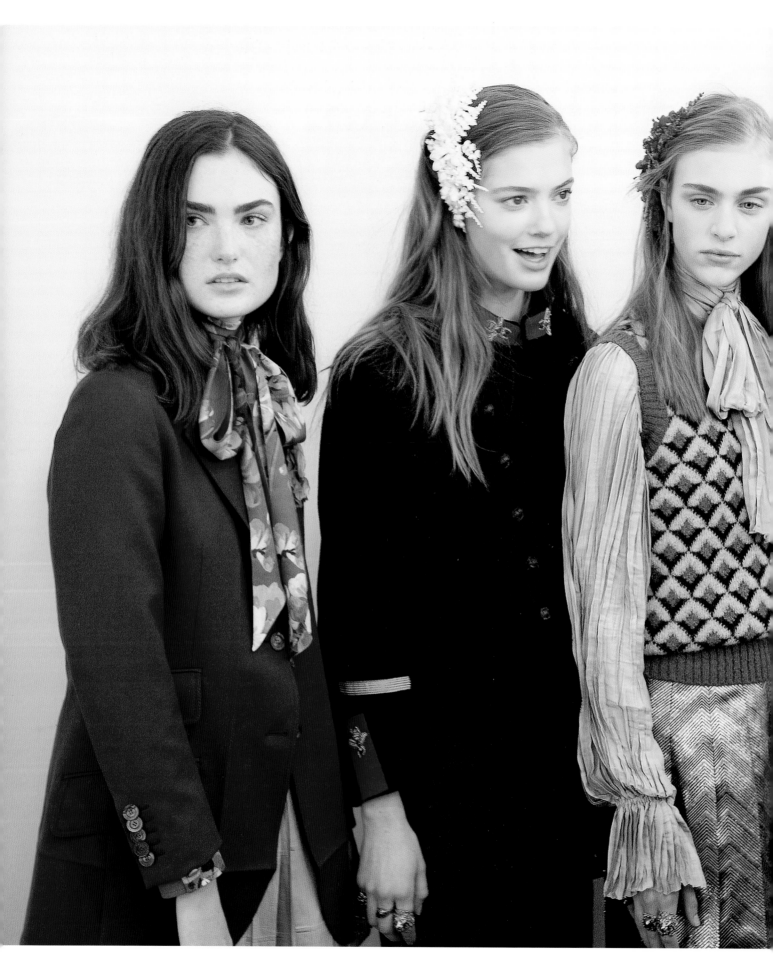

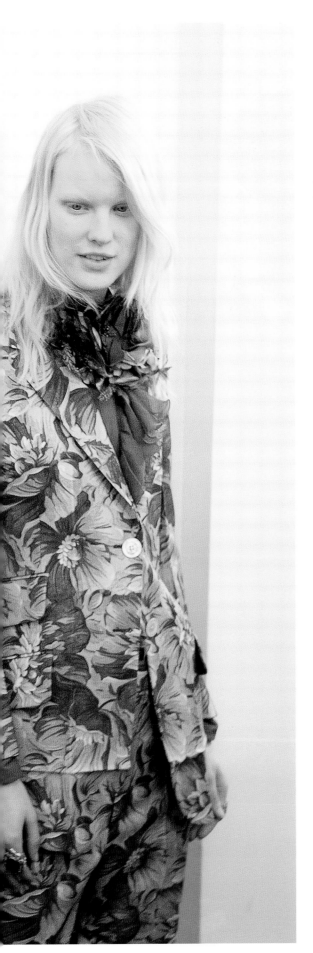

No. 4

GUCCI

Go, Gucci! Ever since creative director Alessandro Michele took over from predecessor Frida Giannini, fashion editors have been going gaga with anticipation for the Florentine label's shows. And showering its quirky chic—pussy bow blouses, brocade suits and accessories like oversize nerd glasses and vintage-style fur coats—with loads of Instagram love. Speaking of Instagram: One of the international shows' most popular "shoefies"? The iconic Gucci loafer.

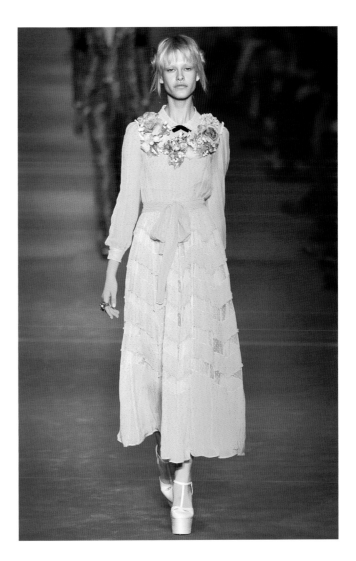

No. 5

PRADA

In the seventies, no one would have guessed
that a professional mime with a Ph.D. in political
science could take over her father's leather
business and transform it into one of the world's
most visionary fashion houses, starting with a
little nylon backpack. Well, Miuccia Prada has
always been one for surprises. Her shows could
best be described as fashion surprise packs filled
to the brim with eclectic references, retro chic
ready-to-wear, and statement accessories.

Milan, Fall/Winter 2016/2017

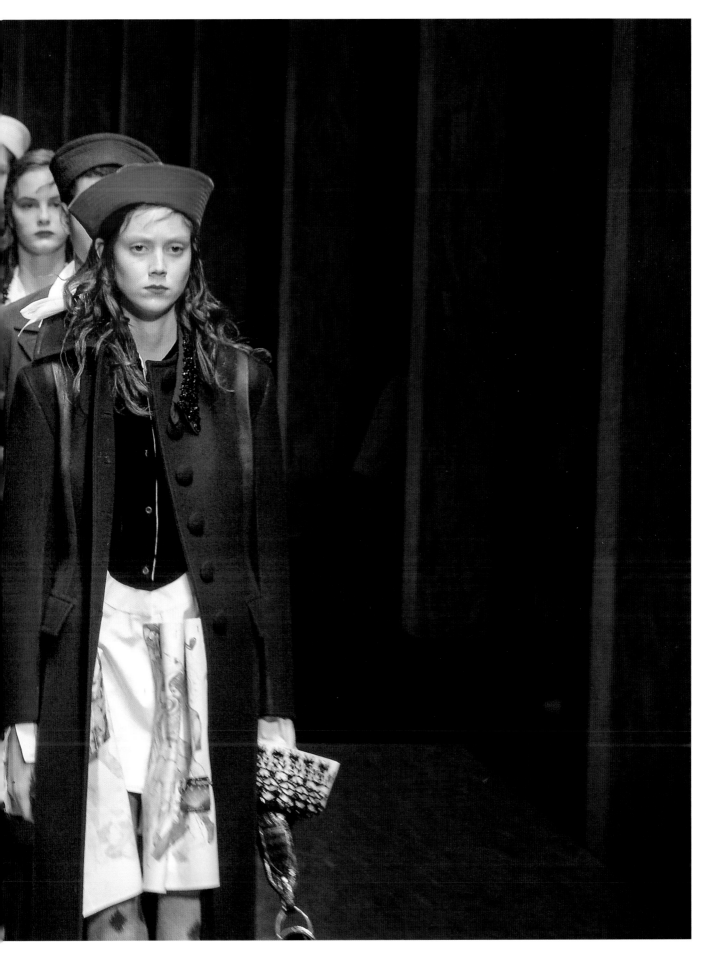

TRENDING

3 To Watch

Stella Jean
130

Fausto Puglisi
132

MSGM
134

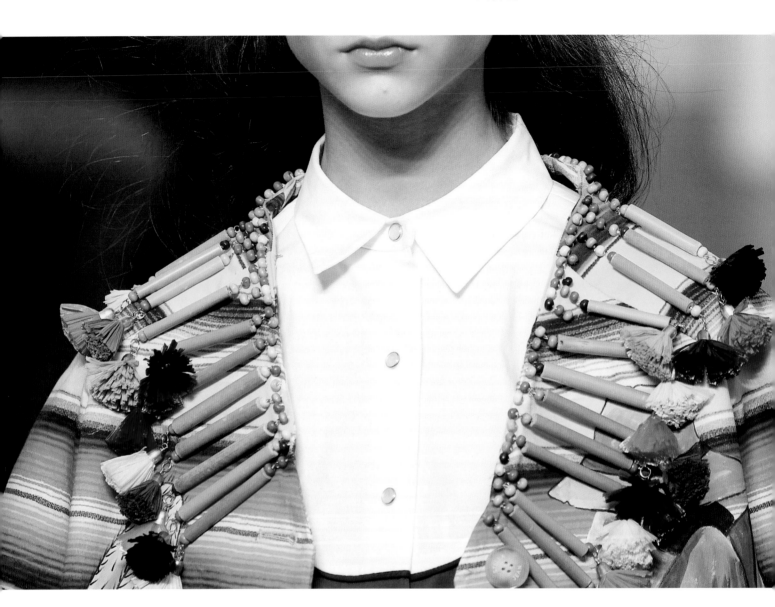

Milan, Spring/Summer 2016

STELLA JEAN

African wax print fabrics tailored into traditionally European silhouettes and styled with streetwear: Growing up in Rome as the daughter of a Haitian mother and Italian father, former model Stella Jean has always enjoyed juggling opposites. Her fashionable balancing act has served her well. Big names like Beyoncé and Rihanna, who wore a Stella Jean dress for her visit to the White House, are fans of her colorfully patterned pencil skirts paired with pinstripe blouses or football jerseys.

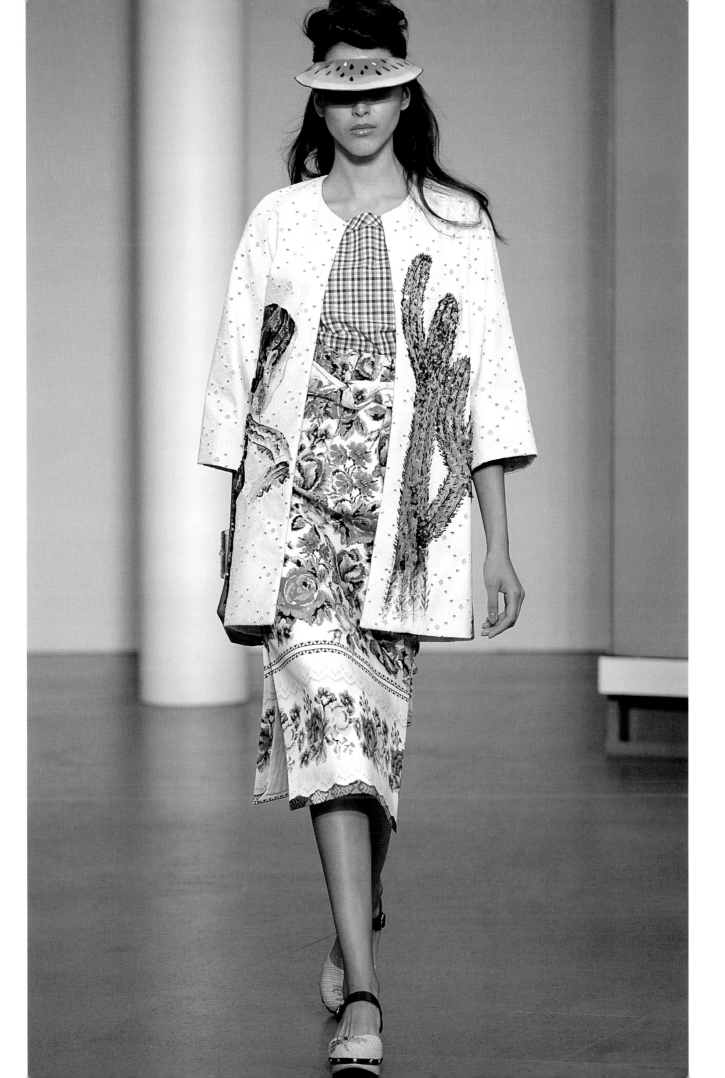

No. 2

« Beauty
is something
that only
Italian artisans
can handle. »

Fausto Puglisi

FAUSTO PUGLISI

Before anyone actually knew his name, Fausto Puglisi was already out there creating stage looks that Madonna hand-picked for her collaborators Nicki Minaj and MIA to wear to her 2012 Superbowl Halftime Show. Then, street style legend Anna Dello Russo was snapped in his sexy gladiator-style dresses. Eventually, Puglisi added elaborate embroidery, zebra and palm prints as well as acid wash pieces to his detail-oriented fashion repertoire. Who might have been the source of his inspiration? Let's just say Gianni Versace would have been proud.

Milan, Spring/Summer 2016

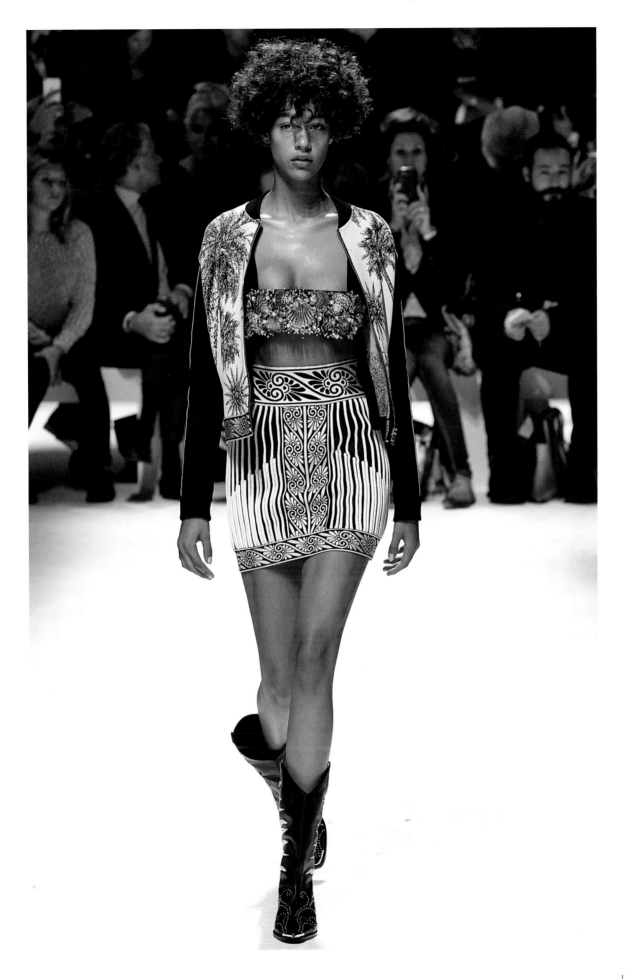

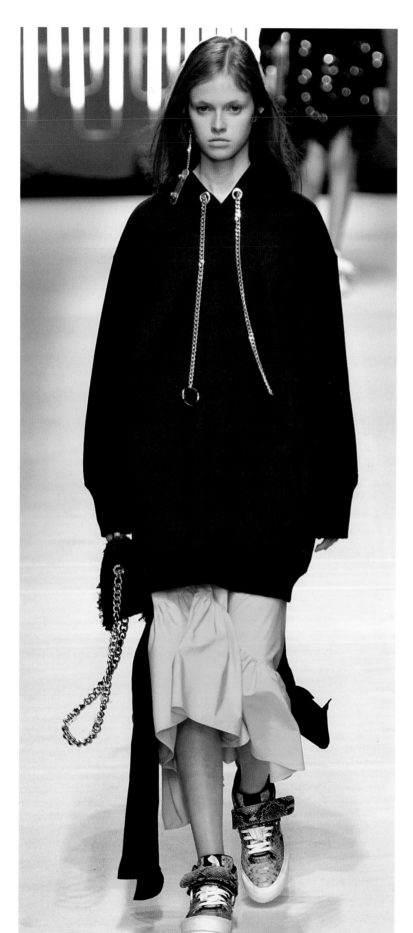

MSGM

With his unorthodox runway debut in 2013, Massimo Giorgetti was one of the young guns subjecting the formerly drab Milan Fashion Week to a welcome youthful facelift: Hawaiian print crop tops met pants with kaleidoscopic, psyche-delic patterns. With the help of his stylist, street style icon Viviana Volpicella, the self-taught designer also threw in block striped bolero jackets and skirts made of rainbow-hued ropes—for good measure, creating a clever fashion discord that has earned his collections both cult and bestseller status almost instantly.

Milan,
Spring/Summer 2014
(right),
Spring/Summer 2016
(left)

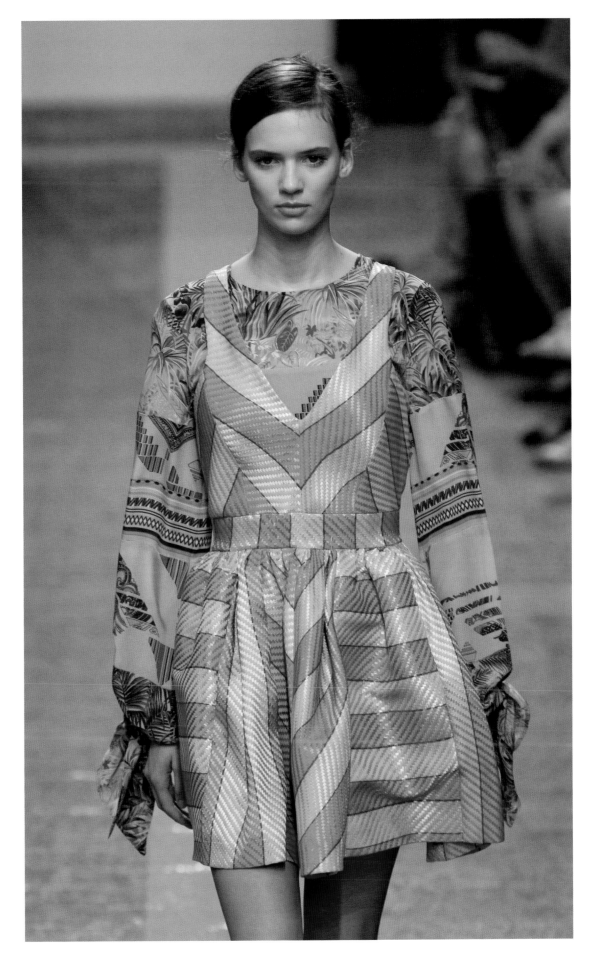

NEVER WITHOUT

by Stella Jean

a white mannish shirt

a striped shirt

a family wristwatch

a "dad's jacket"

a pair of moccasins

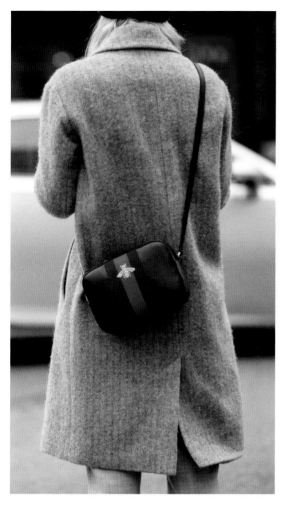

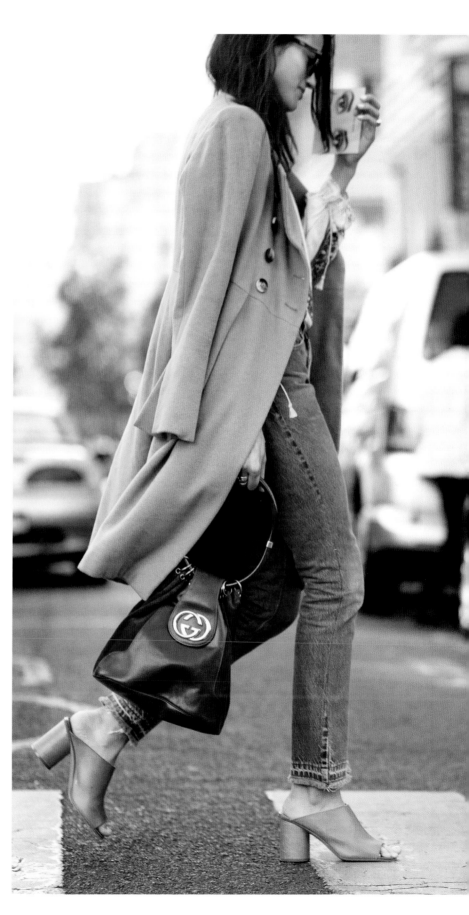

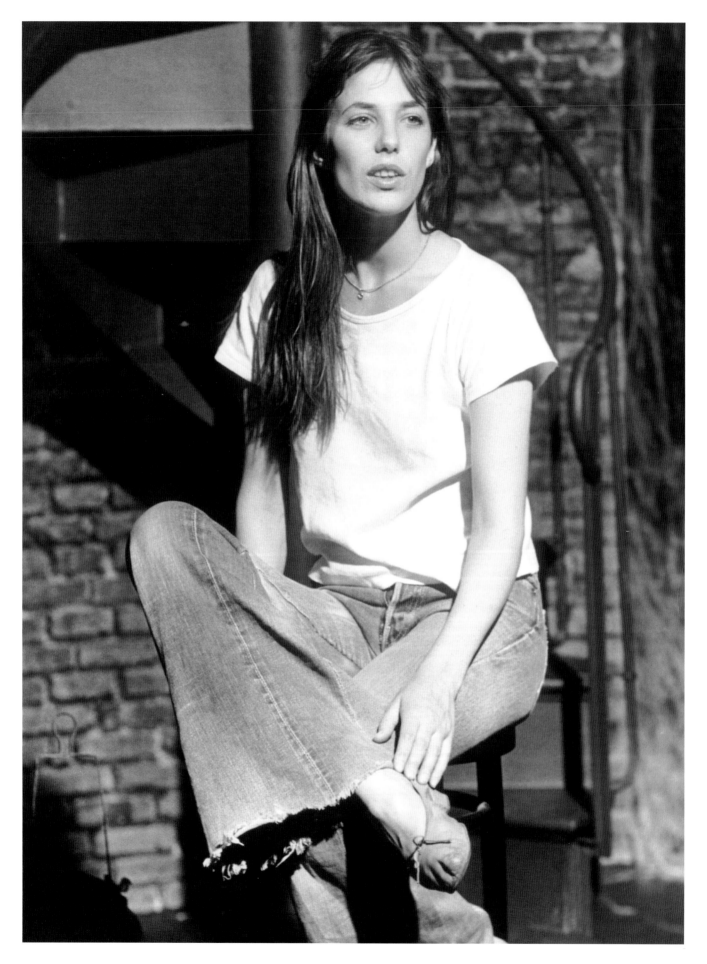

«Blue jeans are the most beautiful things since the gondola.»
Diana Vreeland

DENIM

Denim is my uniform!" Hearing these words out of Fanny Moizant's mouth is quite something. After all, the business concept for her vintage online boutique Vestiaire Collective is based on self-confessed fashion victims selling off their seasonal key pieces to other fashion fans every six months to make room for a fresh batch. Moizant's favorite skinny jeans by Topshop, though, are among the few survivors of her semi-annual closet cleanouts. In Karlie Kloss' case, her Frame Denim jeans would most likely be the ones surviving any sort-out, and in "Man Repeller" Leandra Medine's case, her Levi's 501s. If anyone had told Levi Strauss, the godfather of blue jeans, that his workers' pants made of durable denim would one day become a wardrobe essential for women and men, fashion fans and John Does alike, the native Bavarian would have declared them insane. Not even mentioning denim's victory march on the catwalk! Every designer label, from Alexander McQueen to Versace, has added denim to its collection at some point. Plus, a number of brand new labels like R13 and BLK DNM, which use the highest quality Japanese and Italian denim for their jeans, are competing for spots on the fashion calendar, and rightfully so! Some of them have already morphed into full-blown lifestyle brands. The perfect pair of jeans, after all, needs chic styling partners, explains Jens Grede of Frame Denim. Silk blouses, fitted knitwear, velvet tuxedo blazers and leather jackets: "Sophisticated contrasts will instantly refine your casual denim look."

ESTABLISHMENT

The Big 5

Levi's

142

AG Adriano Goldschmied

144

Diesel

145

J Brand

146

Wrangler

147

No. 1

LEVI'S

Levi Strauss, born in Bavaria, emigrated to the US. In 1873, he applied for a patent together with a tailor long known for his ultra-sturdy work pants held together by rivets. The rest? Is fashion history! The original "waist overall" has since undergone a name change—the term blue jeans wasn't coined until the sixties—along with an upgrade from work wear basic to sub-culture statement to fashion staple in every wardrobe worldwide. But the original trousers' look has hardly changed. Best example: the iconic 501, which has been Levi's best-selling model since 1890.

No. 2

AG ADRIANO GOLDSCHMIED

Whereas the jeans pioneers Levi's and Wrangler initially
focused on functionality alone, Adriano Goldschmied can be
credited with catapulting denim into the premium league.
Launching Diesel, Replay and AG Adriano Goldschmied,
among other brands, he has earned the laurels for the
triumphant rise of brand-name jeans. Designer denim made
in Italy in sophisticated washes, three times the price of a
good old 501—which is still in high demand. Why else
would street style darling Alexa Chung design a capsule
collection for AG for spring 2015?

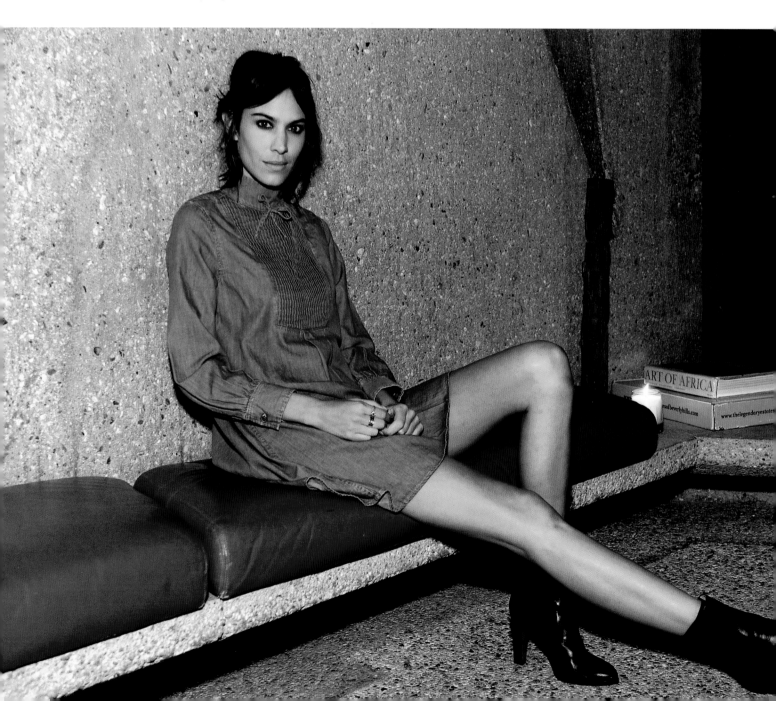

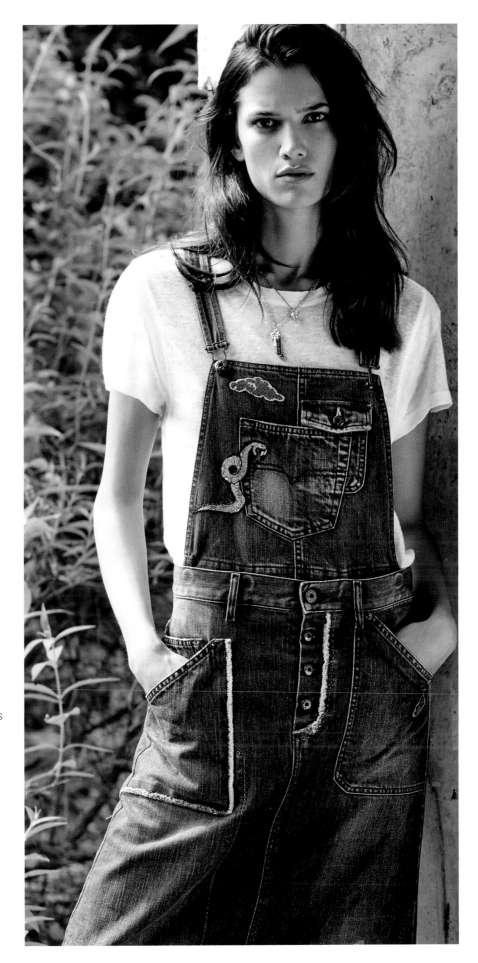

DIESEL

A Diesel campaign once asked—completely ironically, of course—what it would feel like to smoke 145 cigarettes a day. "Be stupid," the slogan read. Which could be understood as Renzo Rosso's motto. The Diesel head honcho couldn't care less about convention. And has been phenomenally successful with his approach: his idea to eradicate denim's all-American image by giving it a punk-chic distressed look made him a billionaire. Resting on his laurels? Not an option! Instead, Rosso's shock therapy continues: He recently hired fashion enfant terrible Nicola Formichetti, Lady Gaga's infamous former stylist, as creative director.

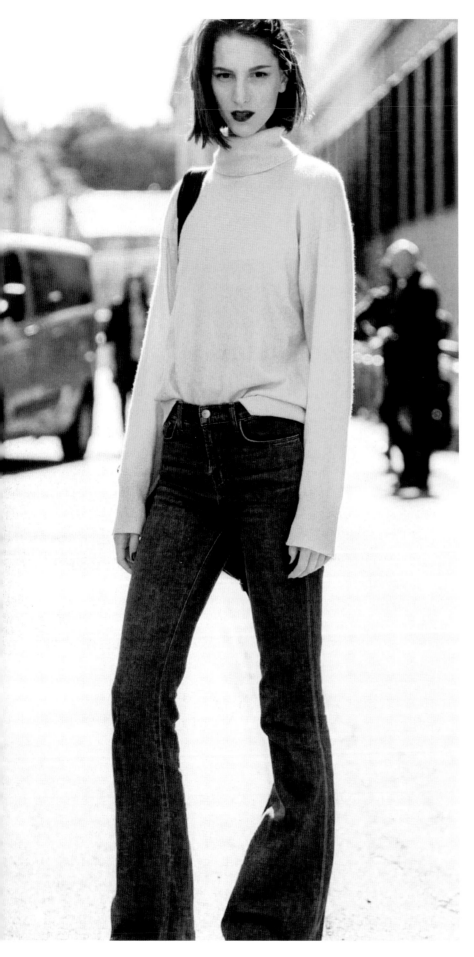

J BRAND

It's 2010. "Paparazzi" is still on heavy rotation. Doesn't matter who those celeb shutterbugs Lady Gaga named her hit single after are pointing their lenses at: chances are that person is wearing a Houlihan by J Brand. Hundreds of thousands of pairs of the slim fitting cargo pants flew over the counters that year. One-hit wonder? Sure! Not a big issue for the brand, though. Years before the Houlihan was even born, fashion insiders were already feting J Brand's skinny styles as the best-fitting stretch jeans ever made. And—lucky us!—the denim label from L.A. actually still makes those.

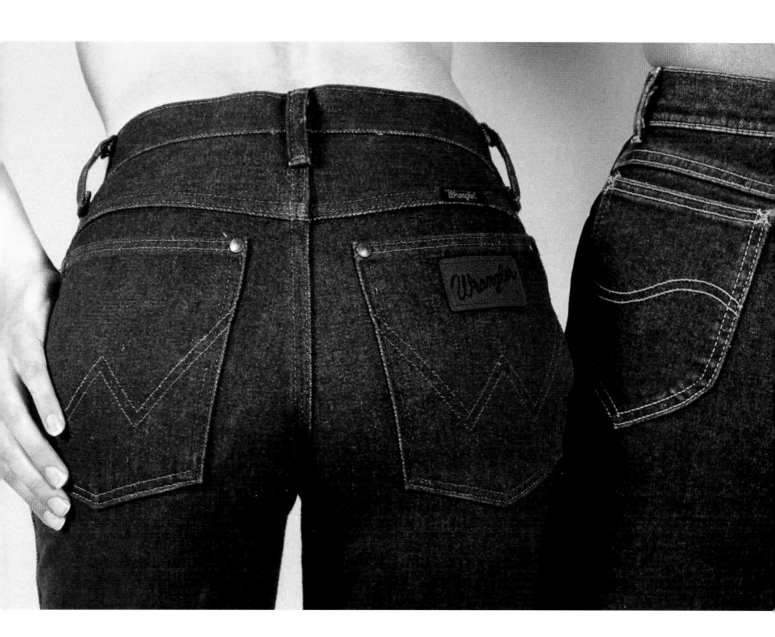

WRANGLER

"What do real cowboys wear? Wrangler!" If you've ever made it to a Professional Bull Riding event in America, you are bound to hear those exact words ripping through the arena's sound system. Ever since Rodeo Ben, celebrity tailor for cowboys and country singers alike, designed the first authentic western jeans for the work wear label in 1947, Wrangler has been famous for trousers that will put up with the extreme wear and tear brought on by real rodeo riding. Success has proven their strategy right. After all, real quality with a dash of Wild West romanticism never goes out of style.

TRENDING

3 To Watch

BLK DNM
150

R13
152

Frame
154

BLK DNM

Leaving the party when the lights come on? After Kimye left for their honeymoon in his customized leather biker jackets, it seemed like that time had come for Johan Lindeberg: After five years, the denim expert bid BLK DNM, his fashion project known for skinny jeans and leather goods with a grungy downtown New York appeal, farewell. But no worries: BLK DNM—along with its illustrious fan base including the likes of Gisele Bündchen, Emma Watson and Mr and Mrs West—will continue to be around.

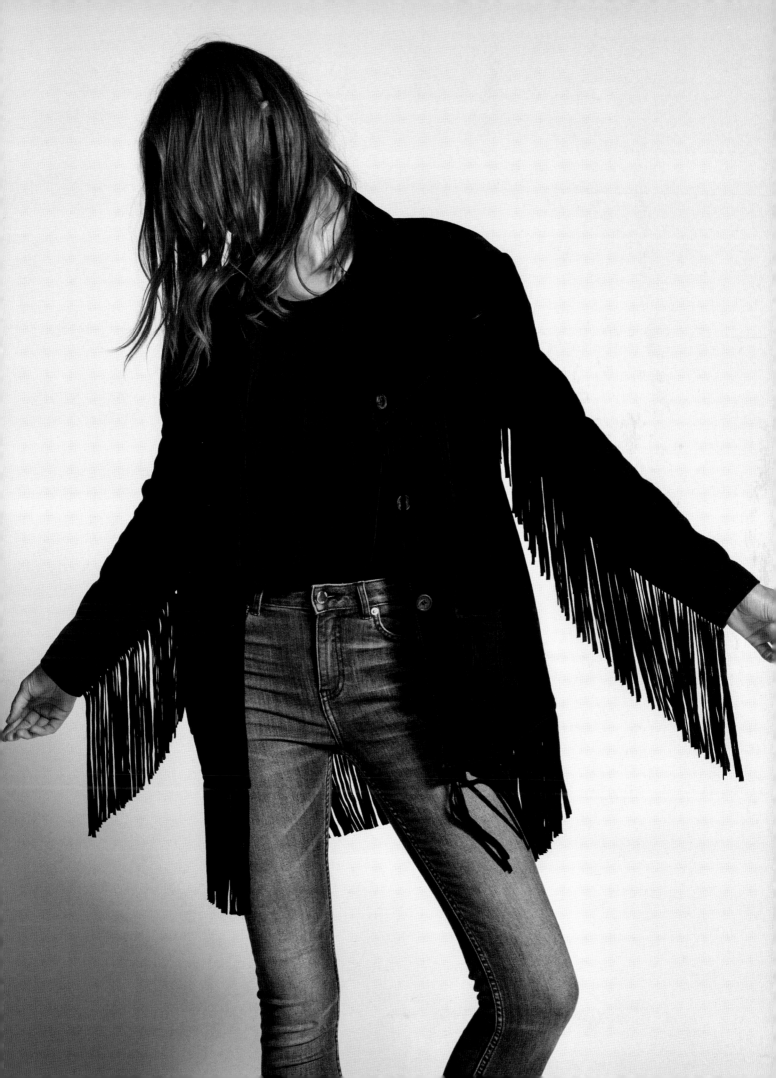

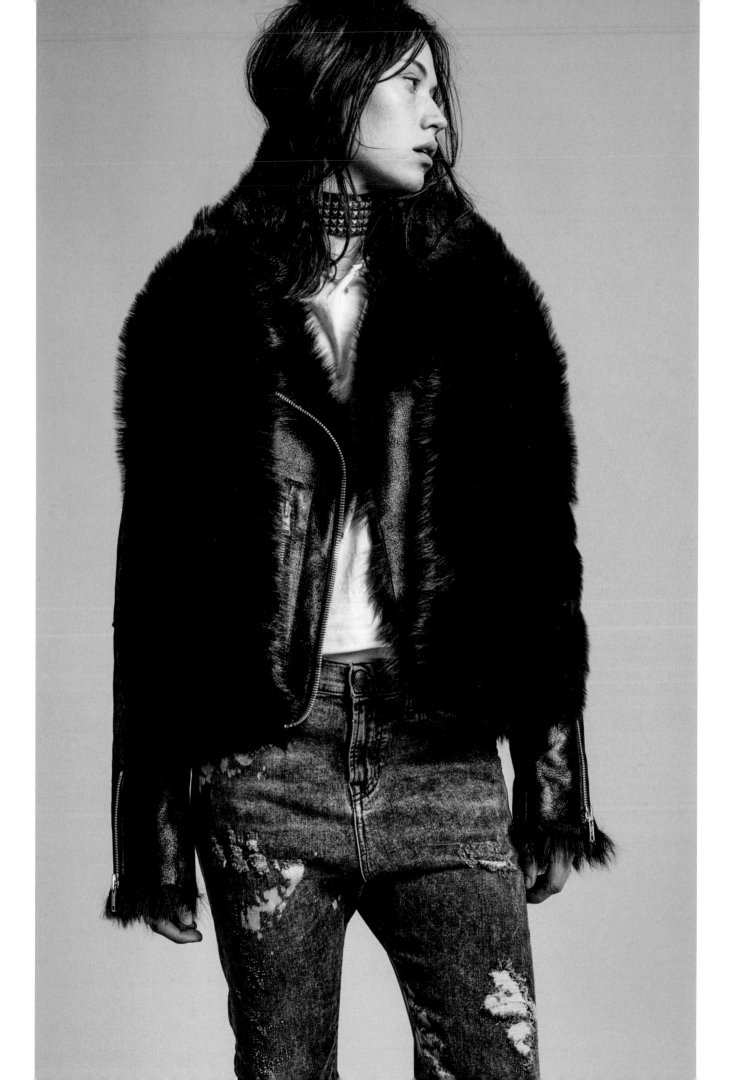

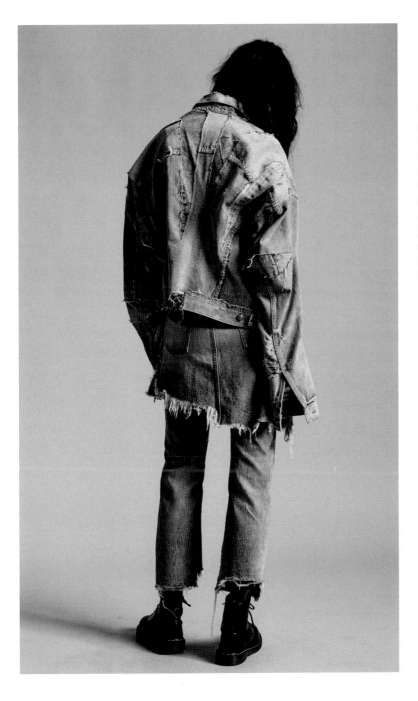

R13

Everyone knows, jeans plus distressed sweatshirt plus leather jacket equals easy airport style. Frequent flyers like Victoria Beckham, Gwyneth Paltrow and Heidi Klum have perfected above-mentioned look. Variable A of choice? Ultra-comfy skinny jeans, joggers or chaps—jeans on top, skin-tight leather pants at the bottom—in dark Japanese denim by R13. The fashion math genius behind this equation? Chris Leba, a Ralph Lauren design team veteran of 20 years, who only revealed his identity in 2016—seven years after he launched his label in New York.

«Denim is always at the heart of what we do!»

Jend Grede

FRAME

High-end, clean denim in classic cuts—ranging from the debut "Le Skinny" to the iconic slim bell-bottoms—turned this label into a fashion crowd favorite in no time. For Jens Grede and Erik Torstensson, whose agency Wednesday has been simultaneously churning out campaigns for H&M, Calvin Klein and Mr. Porter, there is no sweeter proof of success than being able to enlist top model Karlie Kloss to design a line of extra long styles for Frame or creative couple Inez and Vinoodh to create a capsule collection of his and her stretch jeans.

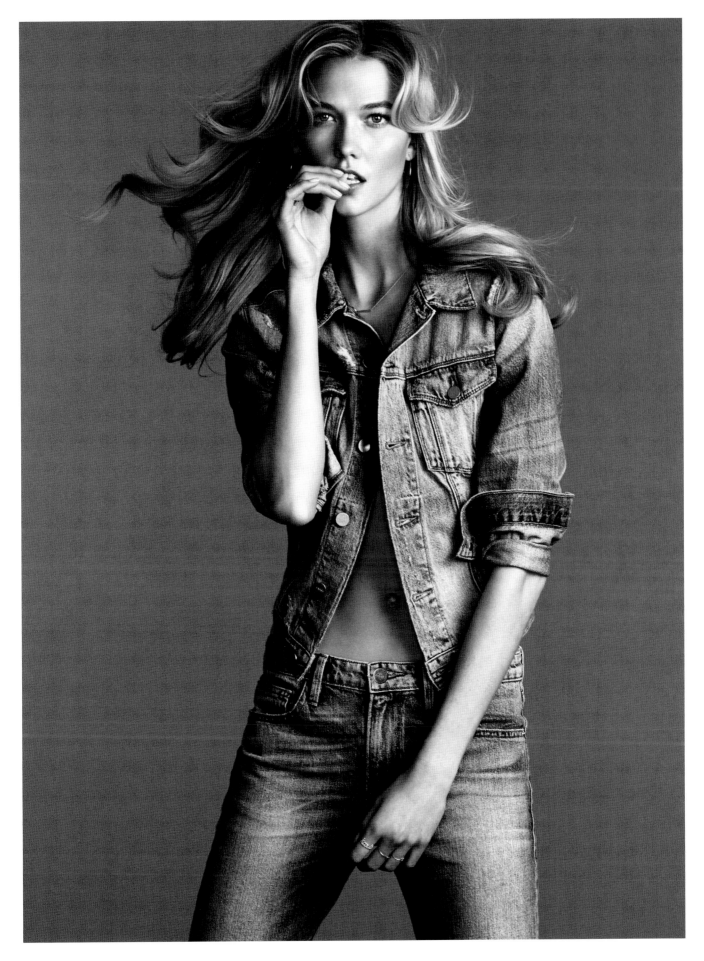

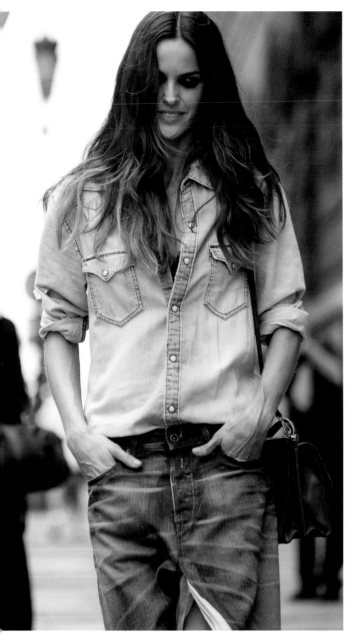

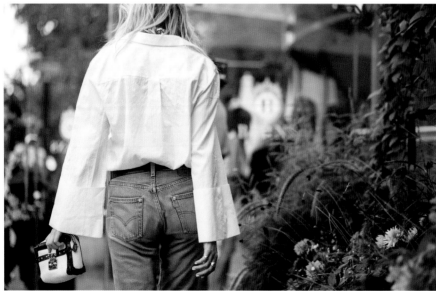

NEVER WITHOUT

by Fanny Moizant

Vestiaire Collective

a pair of skinny jeans,
either blue or black, to wear
every day

cosy cashmere sweaters
from Céline in winter

oversize shirts from Charvet
for warmer weather

denim shirts: one in dark
and one in light blue for the
Canadian tuxedo look

a statement accessory to
embellish a simple denim
look—I love cuffs

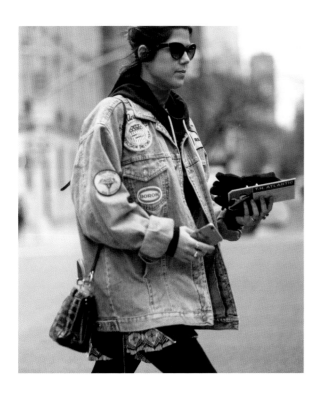

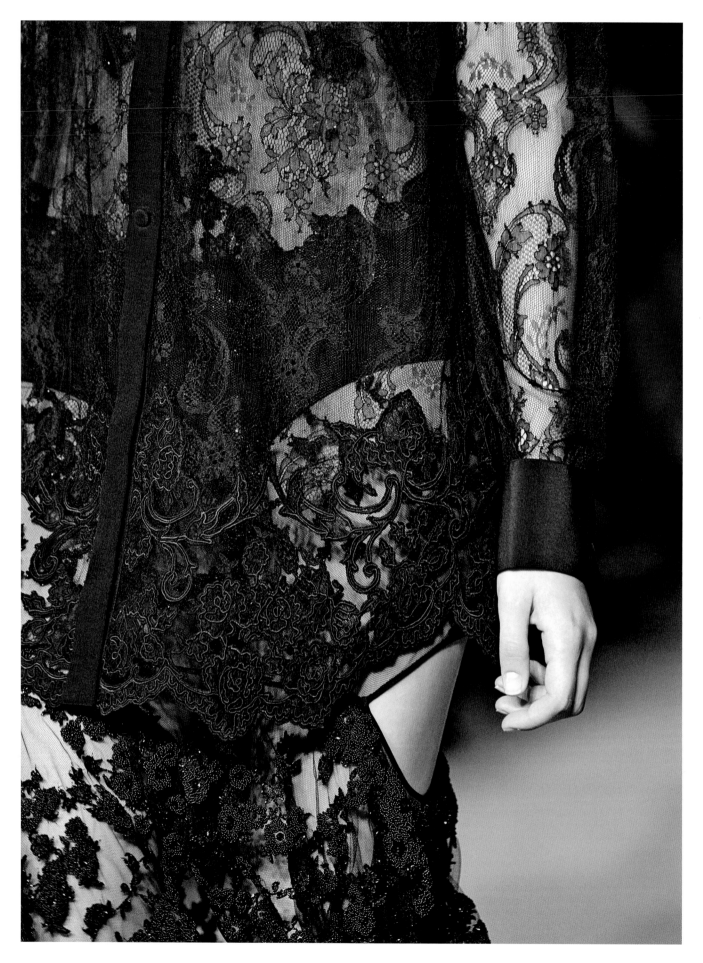

SEXY

Backstage at Victoria's Secret: the room is bustling with 47 girls in pink-striped satin bath robes, either dishing about their workout routines and dieting tips to reporters or having make-up artists render their angelic faces even more luminous. In a few hours, the models—wearing little more than a bra, panties and a pair of wings—will be strutting across a stage showing off their beautifully toned legs honed in countless boxing sessions and ballet barre classes. At the end, a smile and a wink for the audience—live as well as at home. 2000 people get to witness this spectacle called Victoria's Secret Show live in New York, almost 10 million viewers a few weeks later on TV, just in time for the start of Christmas shopping season. Well, sex sells! Especially now that it's more than socially acceptable. Even in high fashion circles, being chosen to become a member of the Angel brigade counts as one of the highest accolades; at

least since super models like Karlie Kloss and Joan Smalls, who have walked for virtually every internationally renowned designer and whose faces ubiquitously grace the pages of glossy editorials all over the world, have a blast taking a stroll on the Victoria's Secret catwalk once a year.

The show doesn't stop at the after party, by the way: On the pink carpet, each one of the Angels tries to outstrip (pun intended!) the other by wearing even shorter hemlines. The masters behind their tight mini dresses and belly button-baring cleavages? Basically all of the following chapter's protagonists. From Anthony Vaccarello to Versace, Givenchy to Alexandre Vauthier. For the 2015 aftershow, the latter created a shimmery gold metallic mini dress for Victoria's Secret veteran Alessandra Ambrosio. On pages 178/179 he lists the sexy essentials every woman who wants to flaunt her femininity needs to own.

ESTABLISHMENT

The Big 5

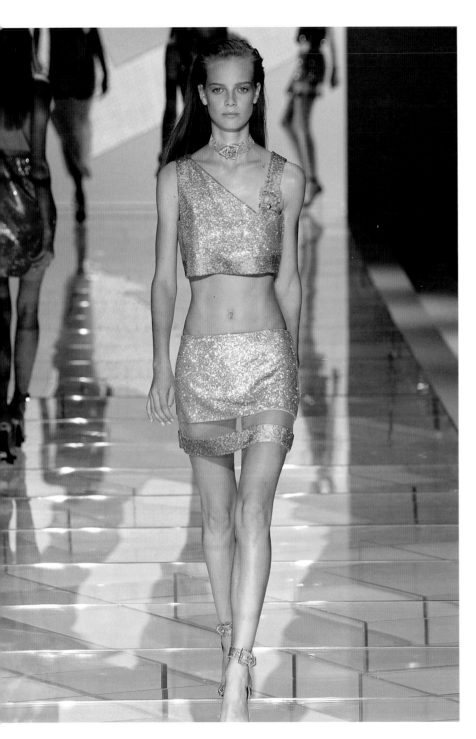

No. 1

VERSACE

"More is more" has always been Gianni Versace's motto. More gold, more glitter, more skin, more heel… His perhaps most legendary creation? That black mini dress, clothing—or perhaps "flaunting" would be a better description—Liz Hurley's slim figure by the grace of a few oversized safety pins. Either way, fast forward: After Gianni Versace's untimely passing, his sister Donatella took over the Italian label. Her collections—made up of ultra-short mini skirts, patent leather jackets and knee-high stripper platform boots—ooze just as much sex appeal as her brother's.

**Milan, Spring/Summer 2015 (above),
Haute Couture, Paris, Spring/Summer 2015 (right)**

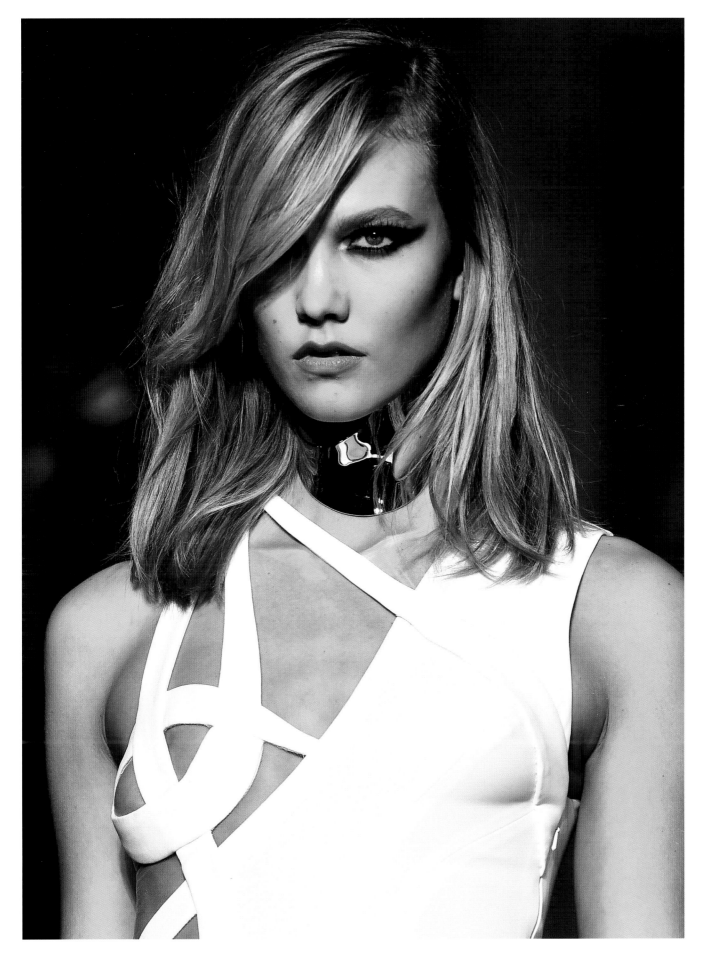

TOM FORD

Tom Ford's design mandate? Bringing sexy back!
During the nineties, the Texan was responsible
for waking the previously prim Gucci from
sartorial hibernation. In 2005, he founded a
lifestyle empire under his own name. The
Ford formula du jour: sophisticated eroticism,
displayed in mini dresses with animal prints
or sequins paired with knee-high boots, and
sensual silhouettes à la Gwyneth Paltrow's
slinky white silk Oscars dress that left little to
the imagination.

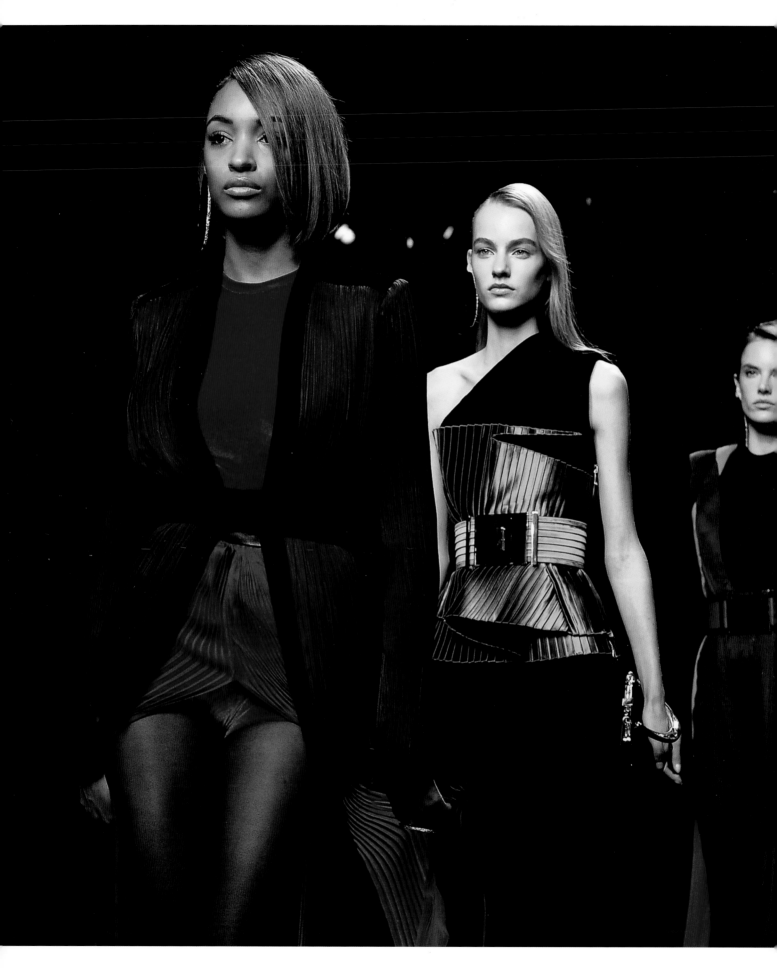

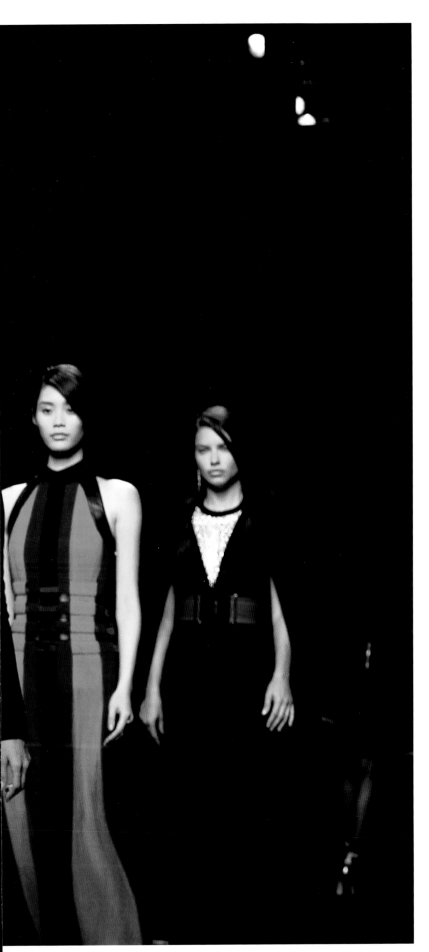

No. 3

BALMAIN

Error messages on the website, scuffles on London's Regent Street: Balmain's collaboration with H&M literally broke the Internet. And all sales records with it. The collection of beaded and sequined micro-mini dresses, blazers with pointy power shoulders and leather leggings sent ebay bids through the roof. To the point where they came ironically close to the five-figure prices of the ready-to-wear collection that young creative director Olivier Rousteing's even younger Hollywood BFFs Gigi Hadid and Kendall Jenner sport whilst hitting the society circuit.

**Paris,
Fall/Winter 2015/2016**

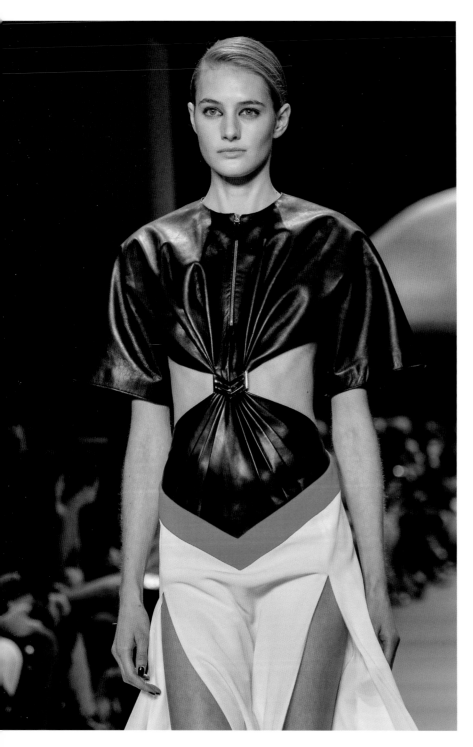

Paris, Spring/Summer 2016

No. 4

MUGLER

In the early nineties, Thierry Mugler dressed the entire fleet of supermodels in his body-hugging designs: Nadja Auermann, Naomi Campbell, Cindy Crawford... They all wore Mugler. Today, creative director David Koma is in charge of the Mugler legacy. The young, London-educated Georgian's muses? A new crew of tall, athletic models, like Karlie Kloss, Joan Smalls and Doutzen Kroes, whom he likes to send down the runway in backless jumpsuits, midriff-baring crop tops and cutout dresses, alternately revealing their collar bones or waists.

No. 5

GIVENCHY

Having grown up with eight sisters, Riccardo
Tisci loves being surrounded by women.
He accompanies them to their weddings
(Kim Kardashian), graces the pages of *Vogue*
(Beyoncé) or vacations in Ibiza (New York nightlife
legend Ladyfag) with them. Dressing them in the
process, of course, comes with the territory.
After all, the creative director of Givenchy knows
exactly how to flaunt his ladies' curves: with
darkly romantic black lace, floor-skimming Gothic-
chic skirts plus masks and face jewels borrowed
from the BDSM scene.

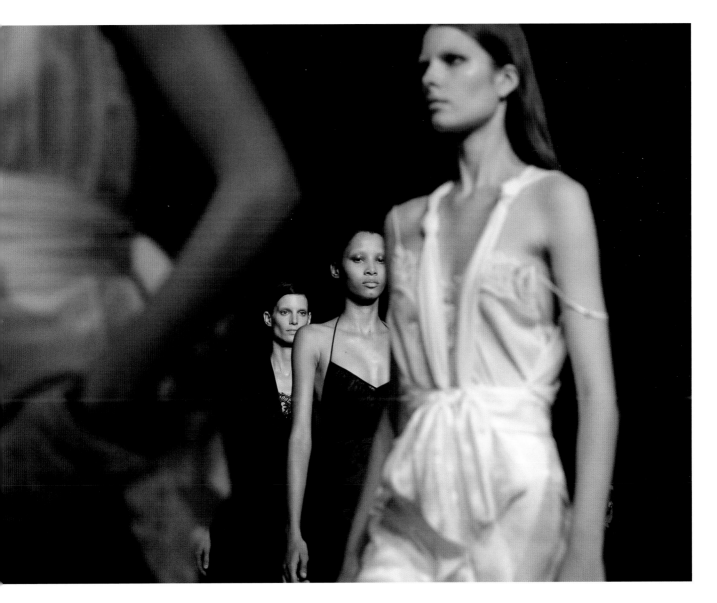

TRENDING

3 To Watch

Anthony Vaccarello
174

Alexandre Vauthier
176

Versus Versace
177

ANTHONY VACCARELLO

Rosie Huntington-Whiteley, Kendall Jenner, Lily Donaldson… To name just a few of the Victoria's Secret Angels who trust the up-and-coming Italian-Belgian designer—known for his asymmetrically slit skirts and generous cut-outs—with their perfect bodies. The former Fendi fur pro's most memorable look went not to a lingerie model, but to Gwyneth Paltrow for her *Harper's Bazaar* US cover. The gown's extra-high side slit not only revealed her entire toned thigh but also her (gasp!) hip bone.

Paris, Spring/Summer 2016

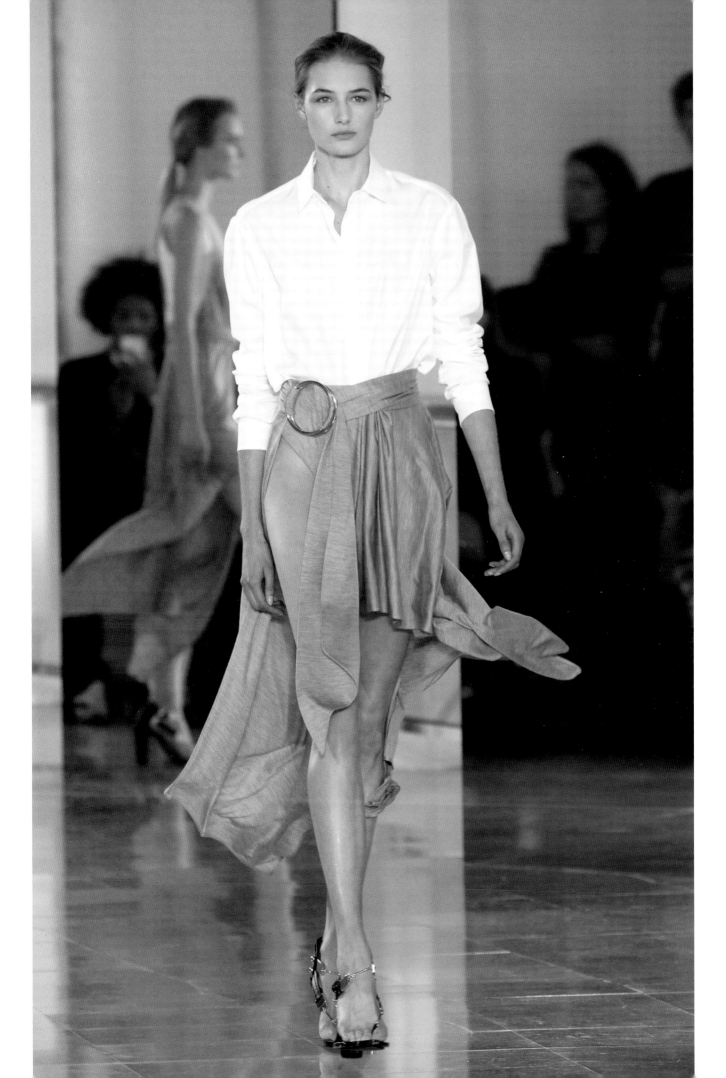

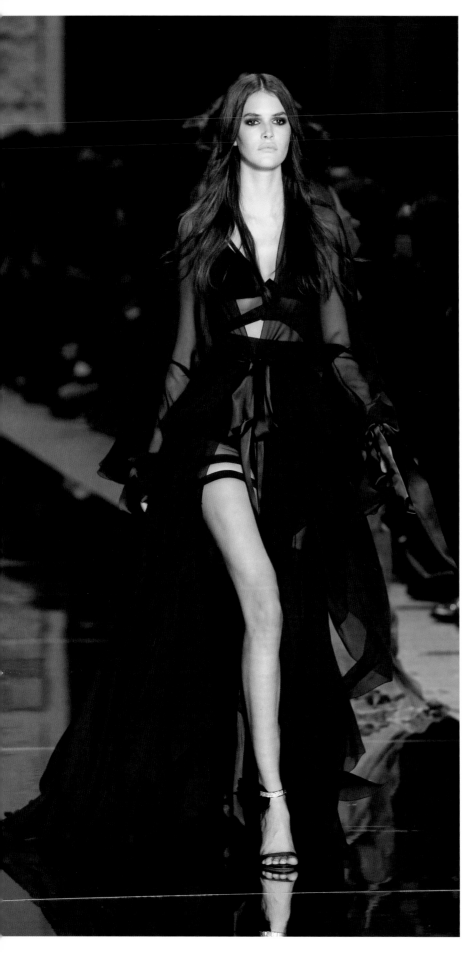

ALEXANDRE VAUTHIER

Trained by supermodel darling Thierry Mugler and couturier Jean Paul Gaultier, who created the legendary cone-shaped bra for the Queen of Pop: when it comes to outfitting divas, Alexandre Vauthier had a head start. His time as an apprentice has paid off handsomely: Madonna wore the Frenchman's bolero for the cover of her single "Girl Gone Wild". Beyoncé chose one of his fur stoles for the album cover of "4". And Rihanna strutted her stuff in a micro-mini dress with pointy shoulders in her video for "Russian Roulette".

Paris, Spring/Summer 2016

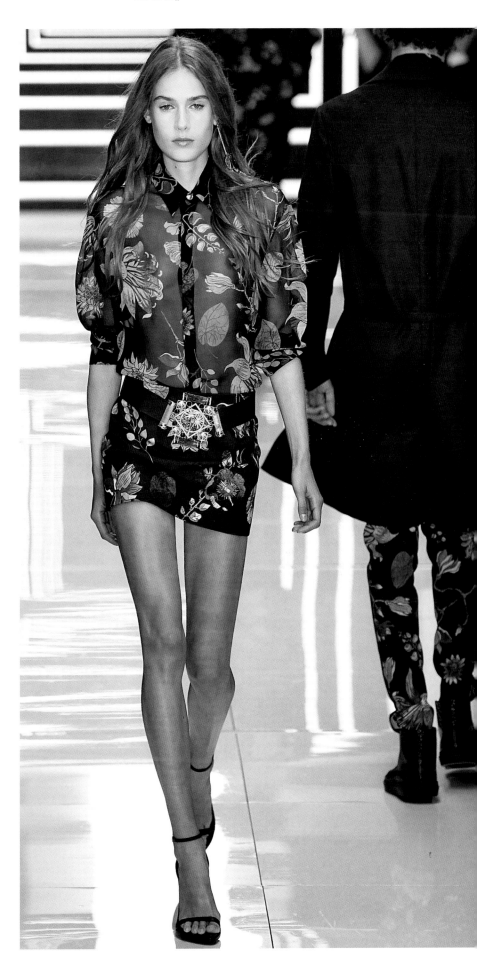

No. 3

VERSUS VERSACE

In 1989, Gianni Versace gifted his little sister a diffusion label, Versus. She, in turn, has been passing on the favor since 2009: After a short hiatus, Donatella chose to revive the line with Christopher Kane, who created a modern version of Liz Hurley's safety pin dress for the Versus comeback. Following his successor JW Anderson, Donatella brought an even hotter contestant on board: Anthony Vaccarello, who has been giving Versus a modern-urban twist with his sexy-sporty homage to role model Gianni.

NEVER WITHOUT

by Alexandre Vauthier

a pepper fragrance

a black tuxedo

a gold metal belt

an open back black dress

black satin ankle strap
sandals with a stiletto heel

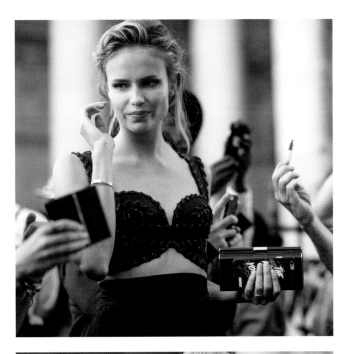

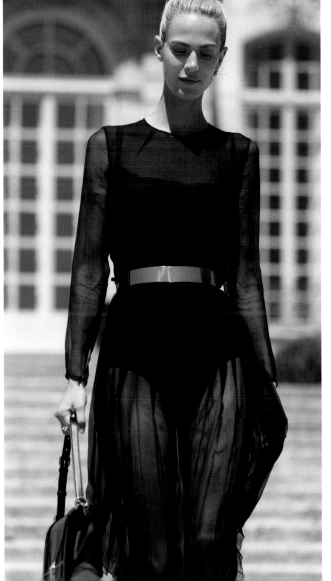

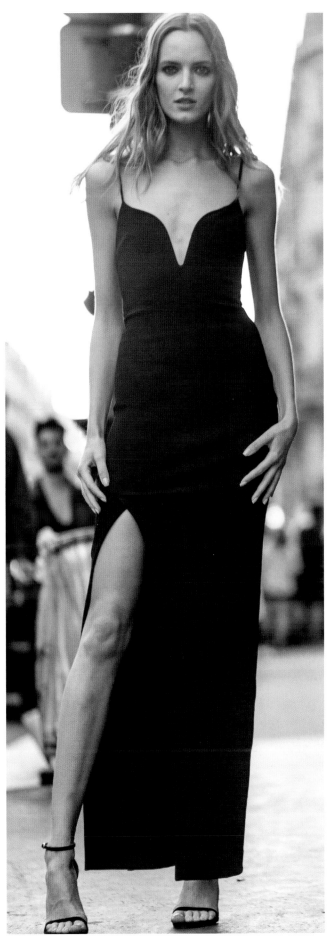

AVANT-GARDE

Avant-gardists don't give interviews. Comme des Garçons' Rei Kawakubo generally prefers having husband and company president Adrian Joffe speak on her and her brand's behalf. Chitose Abe, Rei's Japanese prodigy and designer of the young label Sacai, is similarly reluctant to talk to the press. Most people still don't know what Martin Margiela looks like, even now, after having long left the position as creative director of his Maison.

This shouldn't come as a big surprise. Cultivating an aura of the mysterious is somehow part of the avant-gardist's job description. And in fact, the designers on the following pages are much more than mere clothes makers. They are magicians, masters of their craft, with the skills to elevate fashion to art objects expressing their boldest fantasies. Which might, at a later point, have to be shipped out to photo shoots in room-high crates including meticulous

dressing and repacking instructions. And could come with one trouser leg instead of two, as seen at Simon Porte Jacquemus. Still in his teens, the Frenchman started his career in fashion at—where else?—the dream factory that is the Comme des Garçons boutique in Paris. Closing his surreal spring/summer collection 2016 (pages 196/197) show, titled "Le Nez Rouge" (engl.: The Red Nose), he had models walk out in tandem wearing nothing but white balls of bunched up cotton, indeed reminiscent of a heap of used tissues. "I don't see my fashion as clothes," he says, "I'm obsessed with telling stories." Which, see above, he does best without words. Eventually, someone had to utter a few words at the end of this chapter, which in our case is designer Ayzit Bostan, giving us a list of the essential pieces an avant-gardist dresser should have stocked in her closet. Because even she—unless the name is Gaga—is unlikely to hit the streets in a bunch of tissues.

ESTABLISHMENT

The Big 5

Comme des Garçons

184

Haider Ackermann

186

Yohji Yamamoto

188

Thom Browne

190

Maison Margiela

191

« Fashion is only the right now. »

Rei Kawakubo

COMME DES GARÇONS

Season after season, Rei Kawakubo pushes the limits of what is generally considered fashion. In 1997, the Japanese designer shocked the fashion world with her "lumps and bumps" collection of dresses adorned with tumor-like lumps protruding from waists and backs. Ten years later, she had her models don caps with Mickey Mouse ears. For spring 2016, she went for gigantic red woolen wigs with deconstructed blue gowns. The perfect fit for members of the pop avant-garde like Björk and Lady Gaga, whom we continue to get to marvel at onstage in Kawakubo's creations.

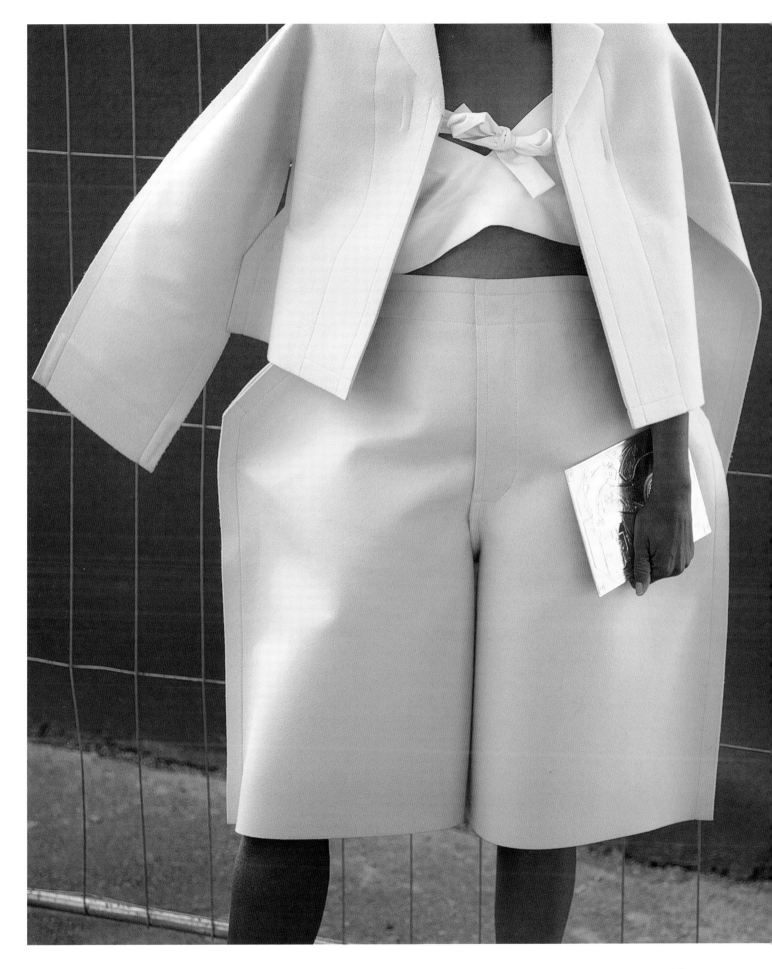

No. 2

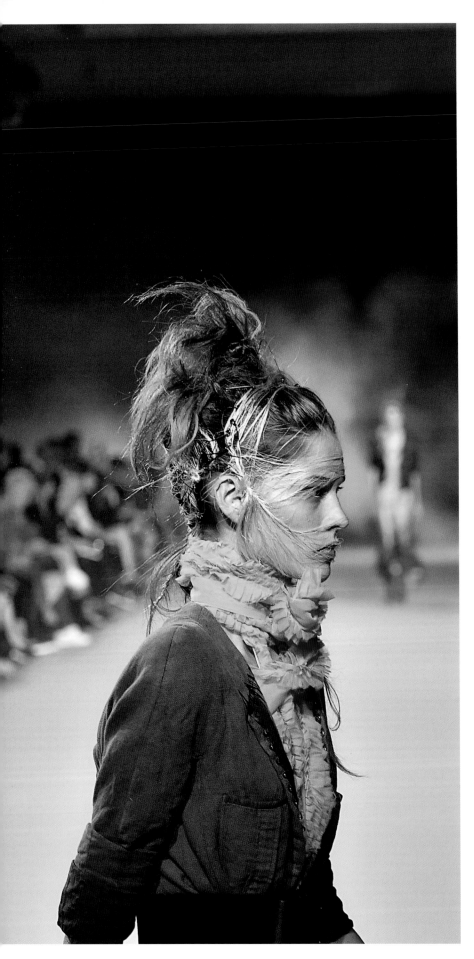

HAIDER ACKERMANN

Haider Ackermann's designs almost immediately conjure up a mental image of Tilda Swinton. On the red carpet, the muse of the Antwerp-trained designer simultaneously exudes ethereal beauty and the earthiness of modern globe-trotters. Be it in expertly draped bias cut dresses or slouchy satin pants with pointy-shoulder blazers made from jewel-colored or patterned silk, the pieces are all inspired by Ackerman's childhood travels with his adoptive father, a French cartographer. Avant-garde light if you will!

Paris, Spring/Summer 2016

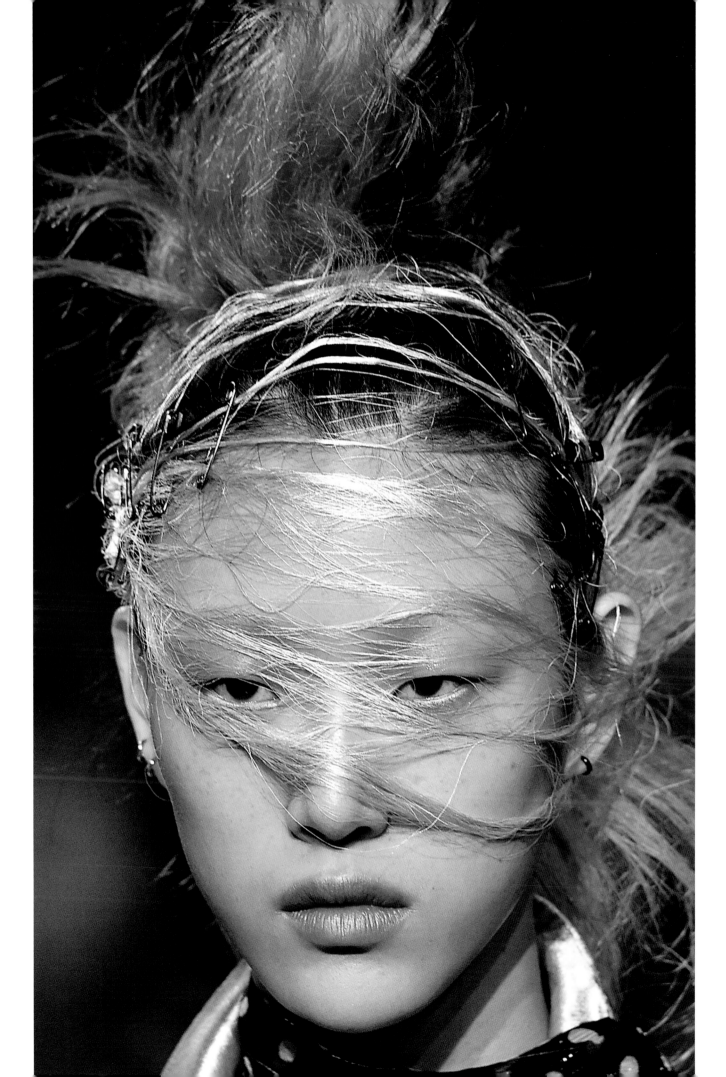

No. 3

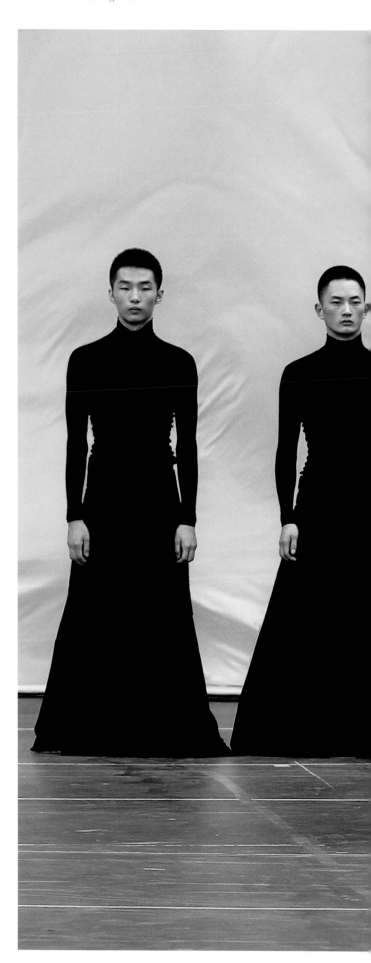

YOHJI YAMAMOTO

As one of the most influential avant-gardists of our time, Yohji Yamamoto creates fashion that transcends trends and conventions (literal translation of avant-garde: "at the forefront"). At a time when unisex looks and transgender models were still distant dreams of the future, the Japanese designer declared that he had always wanted to make menswear for women: oversized, black, expertly tailored. So that's what he did. Ever since, Yamamoto, who is now over seventy years old, has been designing artfully draped wraps, coats and trousers with menswear appeal.

Paris, Spring/Summer 2016

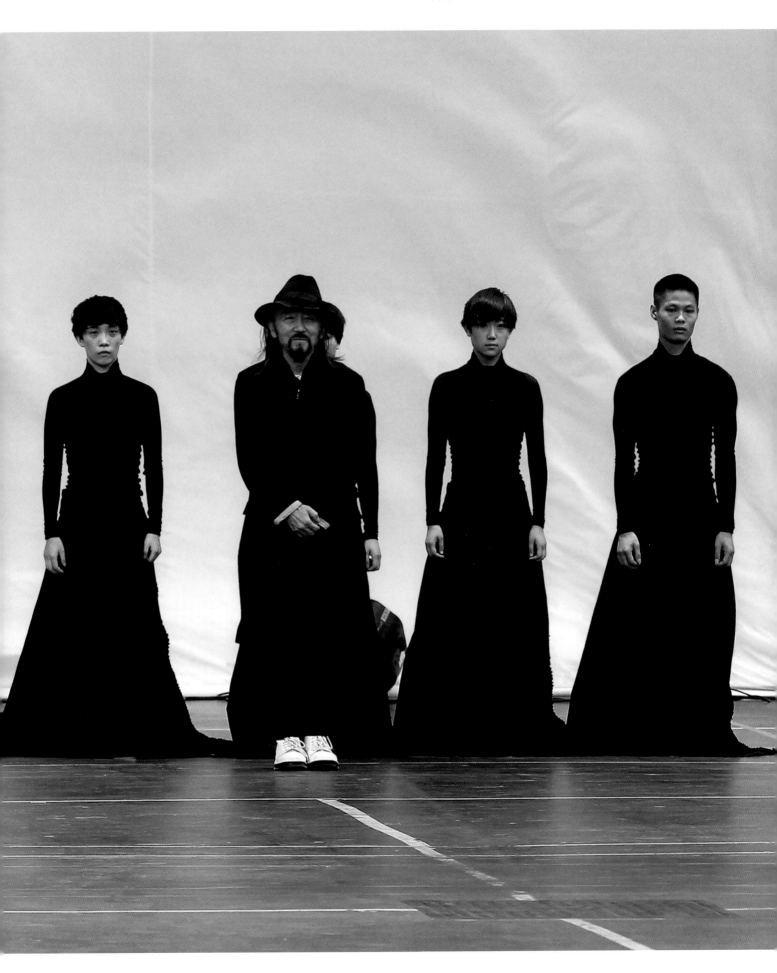

No. 4

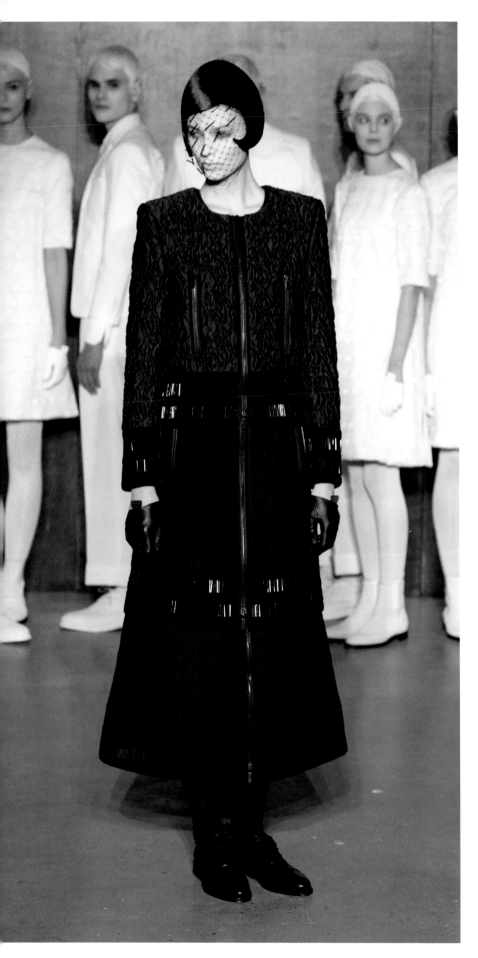

THOM BROWNE

The American design pioneer, who created a tiny menswear sensation with his super slim ankle-length pants and shorts suits, is even quicker to toss conventions out the window with his ready-to-wear women's line. In his shows, he has models rise from coffins with their faces and hands covered in shrouds, or walk in pleated schoolgirl skirts and blazers with braids sticking straight up out of boater hats. Sources of inspiration? Japanese boarding school meets *Alice in Wonderland* or *American Horror Story*. Either way, he'll do anything for a phantasmagoric effect.

No. 5

MAISON MARGIELA

Of all the notoriously unapproachable avant-gardists, Martin Margiela may have succeeded in cultivating the most mysterious aura in the industry. Number of photos of the designer published: one. Interviews given to the press: zero. But where the Belgian designer remained silent, his fashion spoke volumes: pant suits made from seatbelts and seventies upholstering fabrics, deconstructed tops made of recycled leather gloves and split toe boots, created for shock value each season. Today, his successor John Galliano—out of brand character!—makes the headlines, while Margiela has been devoting himself—in total reclusion, of course—to his art.

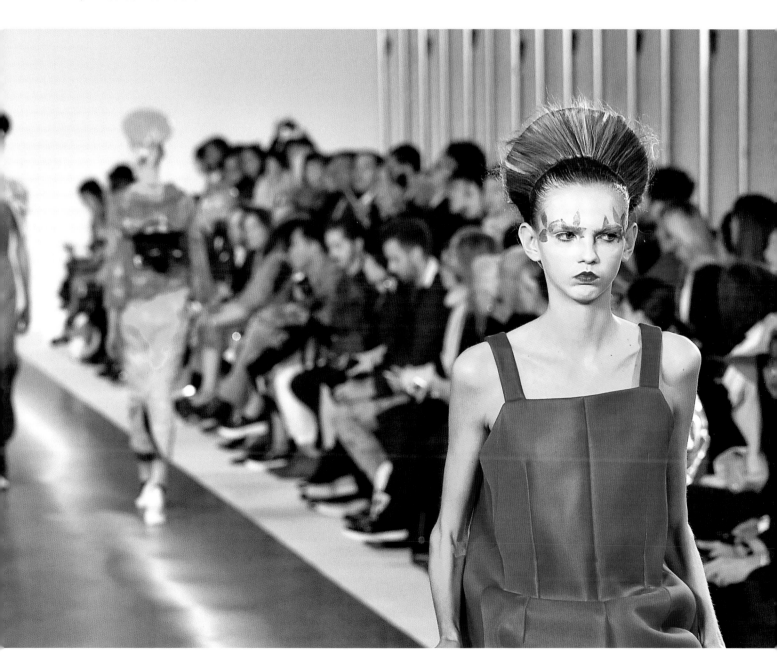

TRENDING

3 To Watch

Sacai

194

Jacquemus

196

Hood By Air

198

No. 1

SACAI

Front like back, top like bottom? No way! Chitose Abe has mastered the art of fashion hybridism: a back panel of broderie anglaise softens up tough military shirts with breast pockets and epaulettes. The designer's dresses could be a puzzle of bomber jackets and chiffon skirts. It's those surprise effects that have won Abe, whose mentors included Comme des Garçons' Rei Kawakubo, acclaim from editors, buyers for the coolest concept stores, and streetstyle icons like Caroline Issa since her Paris runway debut in 2011.

Paris, Spring/Summer 2016

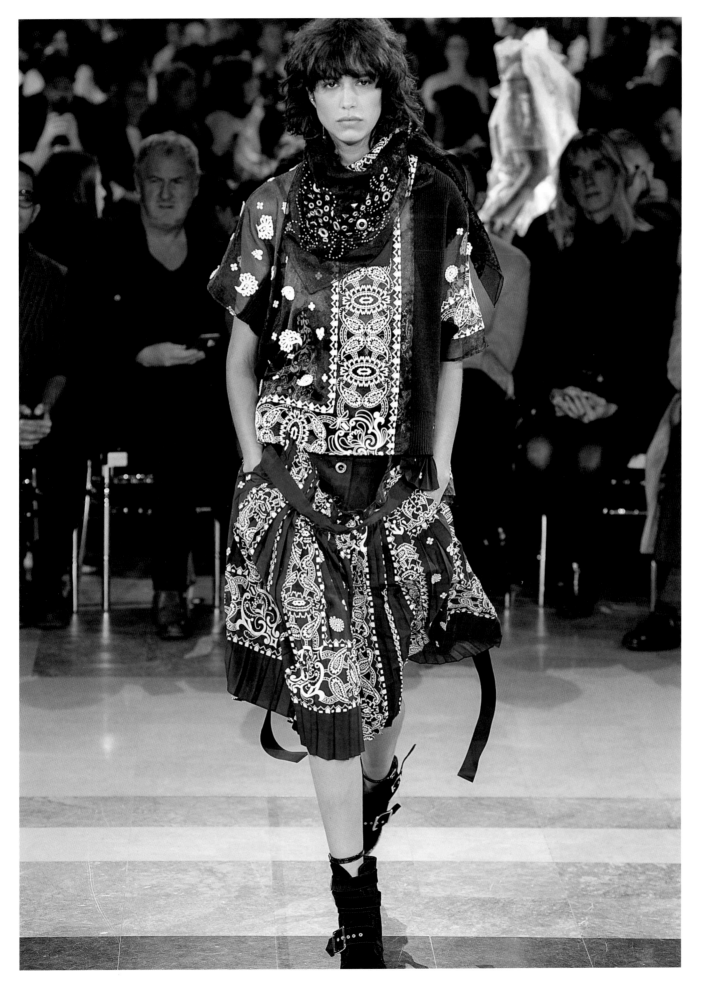

No. 2

JACQUEMUS

"Naive, raw and smiley," that's how Simon Porte Jacquemus describes his collection, which he launched when he was only 19 years old. Well put! In fact, the young Frenchman tailors conceptual pieces in geometric silhouettes—from pink egg-shape coats to deconstructed and pieced together white shirts—with the enthusiasm of a child. Clothes that may require a second or third look to completely comprehend.

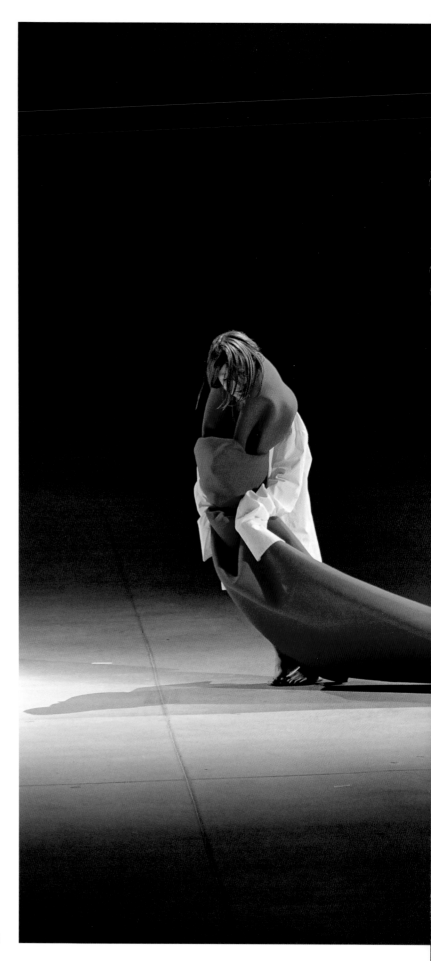

Paris, Spring/Summer 2016

No. 3

HOOD BY AIR

Fashion that renders gender boundaries superfluous is having quite a moment: transgender models are popping up in campaigns, unisex collections on the runways. What is just now gaining traction in the high fashion world, the collective surrounding Shayne Oliver, Hood By Air, has already perfected over the last few years. At his shows, the young designer sends models discovered in New York clubs or on the subway down the runway in gender-bending anti-fashion looks. Always a staple: the signature long-sleeved shirt with the HBA print. Unisex—obviously.

**New York,
Spring/Summer
2016**

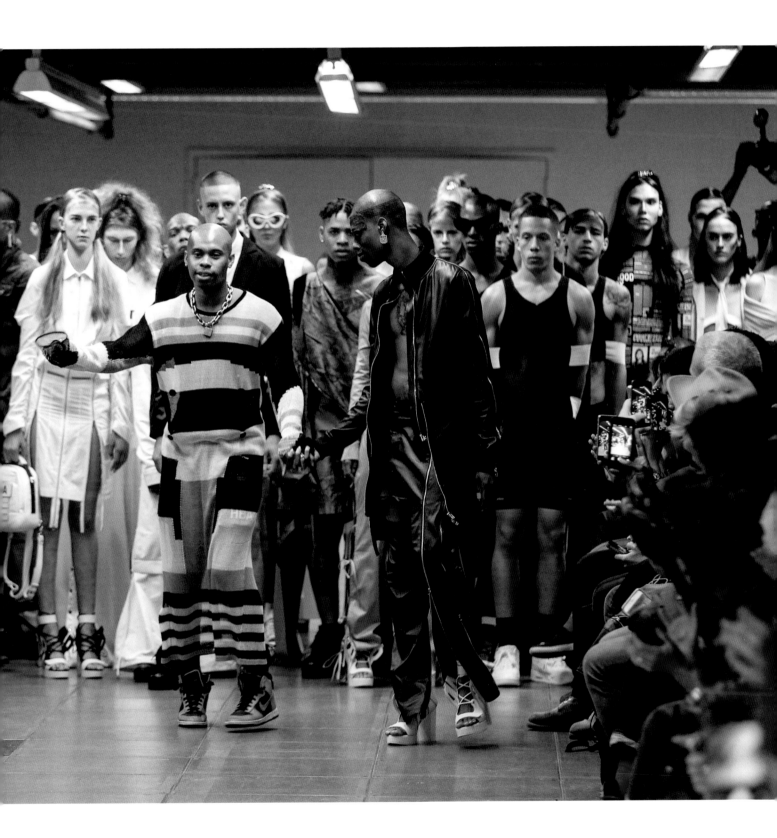

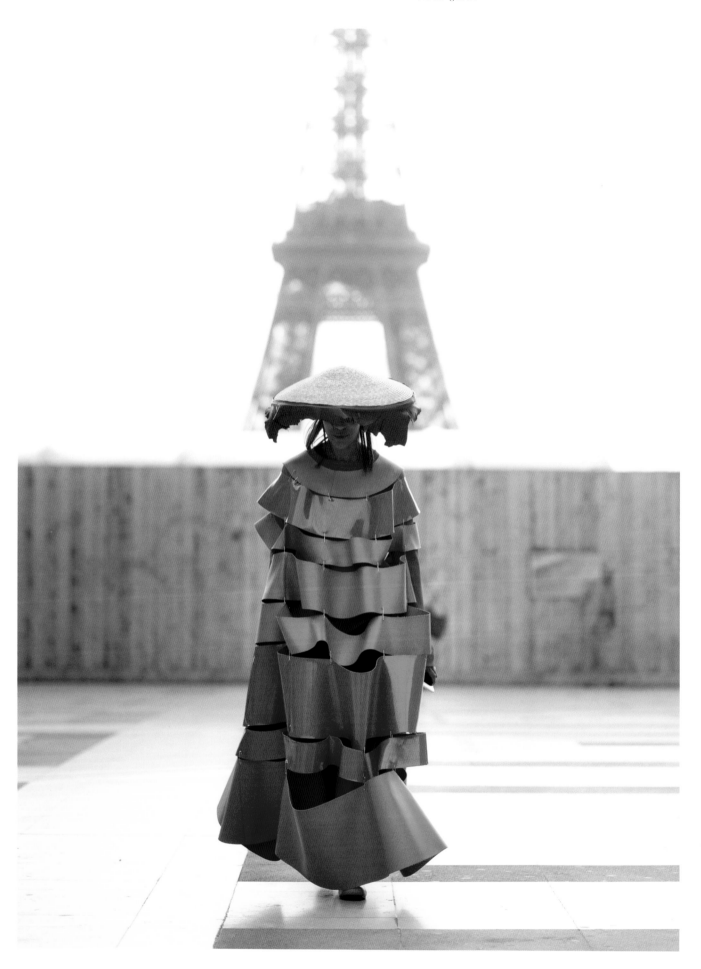

NEVER WITHOUT

by Ayzit Bostan

a long slim coat

a long cashmere sweater with
deep v-neck

shades

a Tank Solo by Cartier

loafers by Robert Clergerie

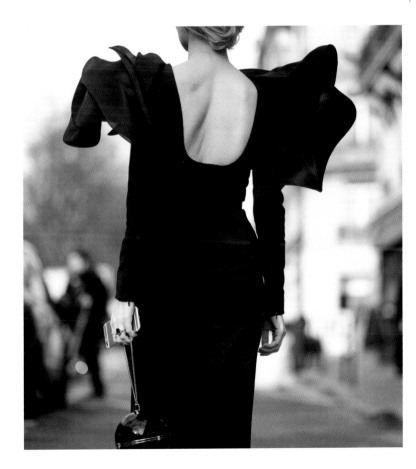

THE HOUSE OF

The minute it was announced that Alber Elbaz was to leave Lanvin, the guessing game began.

Who will take his spot? Will the little guy with the big glasses move on to Dior, where he would be succeeding Raf Simons, who parted ways with the house a few days prior to Lanvin's bombshell? In less than four years, the Belgian created twenty collections—with too little time to complete any of them, he claimed—and modernized the codes of the House of Dior, which before him John Galliano had interpreted as opulent romantic fashion fairytales. At Simons' first haute couture show, slim-fitting black trousers intercepted the obligatory evening gowns. For his spring/summer collection 2016 (pages 206/207), he loosened up the tight hourglass silhouette of the fitted Bar Jacket, Dior's signature piece. Instead, black jackets fell loosely over his models' hips. In stark contrast with extra tight chokers that had enameled pendants imprinted with "1947" dangling from them. An homage to the year of Christian Dior's very first collection and the beginning of his famous New Look. Why New? Because after years of WWII hardship, he re-introduced into wardrobes what women had been missing for so long: glamour.

Speaking of, Balenciaga was also ready to ring in the new: A few days before Elbaz' departure, headlines read that Vetements prodigy Demna Gvasalia would be taking over Alexander Wang's position. Wang had started out in Paris in 2012, on a mission to soften the austere lines of the house with his successful amalgamation of sports- and street wear styles in order to appeal to a younger clientele. His last collection for Balenciaga (see pages 214/215) was perhaps his best, critics argued: He transported his usual crew of grungy looking muses—from Elvis's granddaughter Riley Keough to Zoë Kravitz—from the streets into boudoirs: by ways of silk loungewear made from ivory-hued lace. A considerably laid-back contrast to his predecessors' drive for constant innovation, Wang explained. Cristóbal Balenciaga, who established his fashion business in Spain in 1919 and moved to Paris in 1937, became famous for his sculptural designs (egg-shaped coats! balloon skirts!) that were far ahead of his times. In 1957, the fashion pioneer even caused a mini scandal when he single-handedly decided to present his collections to the press only one day before the arrival date in stores, instead of the customary four weeks. (Funnily enough, Gvasalia's Vetements has adopted a similar concept of immediacy to shake up today's fashion industry.) In 1968, six years prior to his death, Balenciaga closed the doors of his house. In 1997, Nicolas Ghesquière brought it back to life.

Almost 20 years later, after having arrived at his new work station at Louis Vuitton, the Frenchman has given his sci-fi visions free reign yet again: trousers with spaceship prints,

laser-cut leather, knitwear adorned with iridescent beading—inspired by video game heroines, futuristic manga girls and cult director Wong Kar-Wai's movie, 2046 (pp. 210/211). A contemporary interpretation of the maison's central theme: Ever since 1854, Louis Vuitton has been all about travel. That being said, its founder, Louis Vuitton, didn't offer ready-to-wear collections in the early stages, but focused on luxurious luggage made of practical water-proof canvas imprinted with the LV logo.

If it weren't for Monsieur Louis Vuitton's invention, by the way, Karl Lagerfeld wouldn't know where to store his famous iPod collection when he travels the world. His personalized Vuitton trunk supposedly houses up to 20 of his favorite musical tech toys. Returning the favor for this swanky custom-made piece, he famously designed a pair of boxing gloves and a punching bag in monogrammed canvas for Louis Vuitton's 160th anniversary. Then, he of course also designs for Chanel, among others. Fashion icon Coco famously built that house in Rue Cambon, Paris; Lagerfeld took over as creative director in 1983 and with every collection—ready-to-wear, couture, his arts-and-crafty Métiers d'Arts—and the elaborate show to go with it, he reinvents himself: His super models—dressed in ever-evolving versions of the signature bouclé suit—would one show day walk down the aisles of a supermarket with shelves chock-full of Chanel-branded cereal boxes, take a stroll in a garden filled with mechanical flowers on another (pages 208/209) or prance around a Salzburg castle wearing lederhosen and loden jackets.

Who in the world could ever succeed Karl Lagerfeld at Chanel, come the day? Could it be Plan B for Elbaz?

Of course, we could keep on speculating, going around in circles forever and ever. Fact is, before the CEO of one of the luxury conglomerates controlling these Paris fashion houses has not publicly addressed any of the above questions, they will remain a brew of rumors on fashion websites and blogs. And even once the executive does speak out, that brew will continue to boil until the newcomer's first collection, which will reveal how he or she is going to interpret the company's traditions. Or is going to put completely novel ideas into practice. Should the latter be the case, an elegant Le Smoking, interpreted by Yves Saint Laurent for women in the 1960s, might suddenly be replaced by—oops!—rock chic gowns designed by L.A. skate punk fan Hedi Slimane (see Saint Laurent on pp. 212/213). And by the time this book goes into print, style might have taken a new direction entirely. That's why this chapter is simply titled "The House of" and lists only the biggest Paris fashion houses whose even bigger names will survive—no matter how often their occupants choose to change the wallpaper.

THE HOUSE OF

DIOR

Paris, Spring/Summer 2016

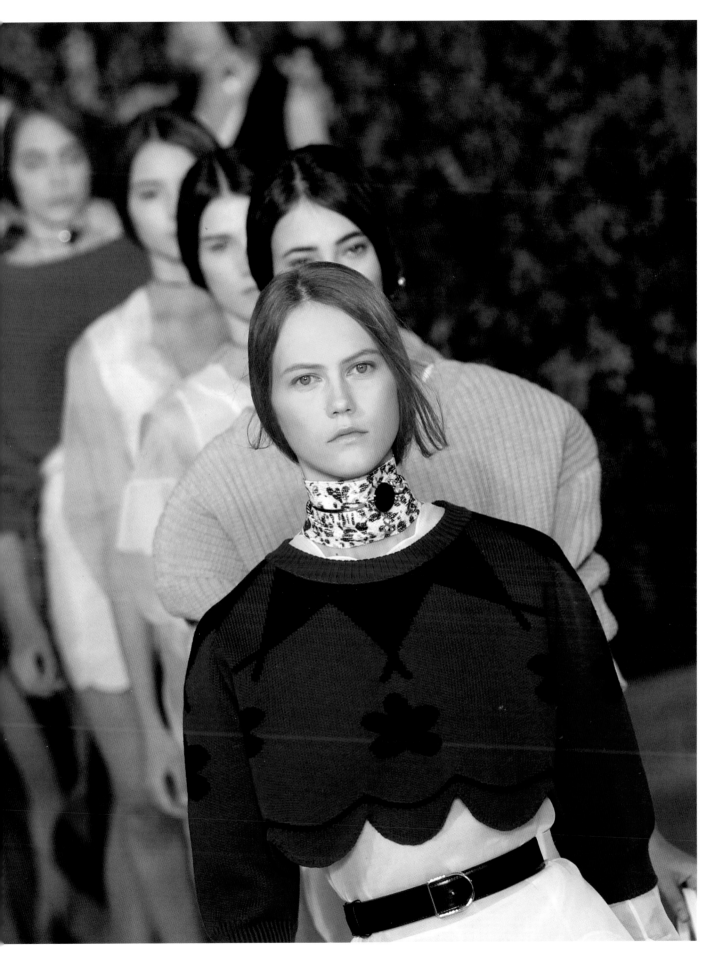

CHANEL

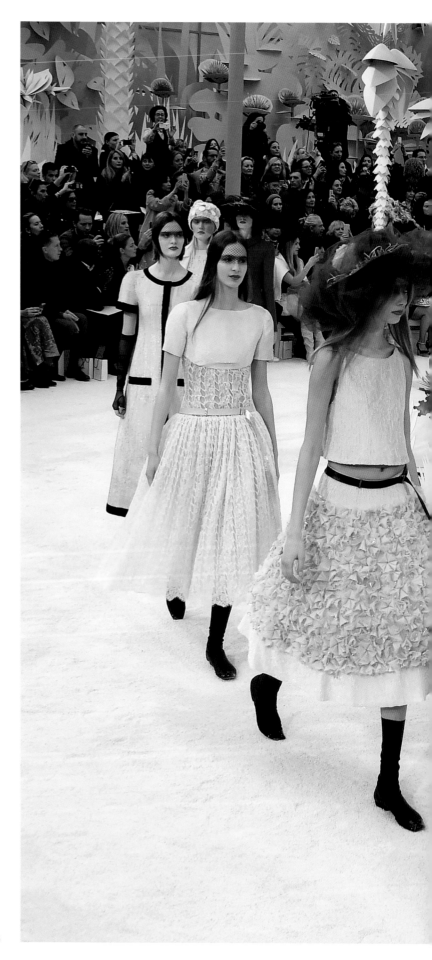

Haute Couture, Paris, Spring/Summer 2015

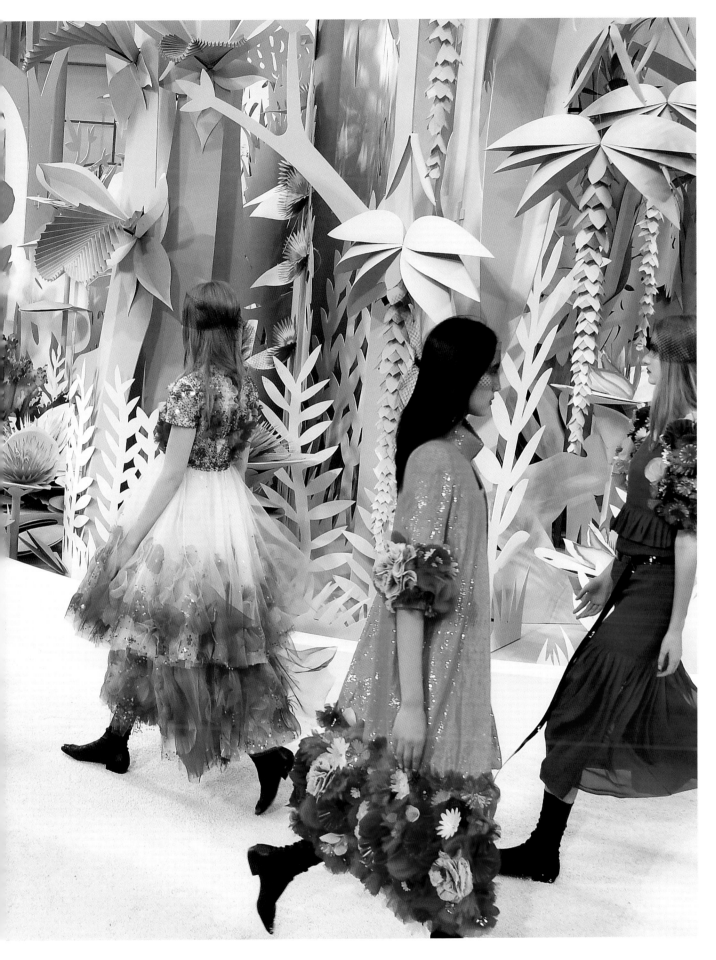

LOUIS VUITTON

Paris, Spring/Summer 2016

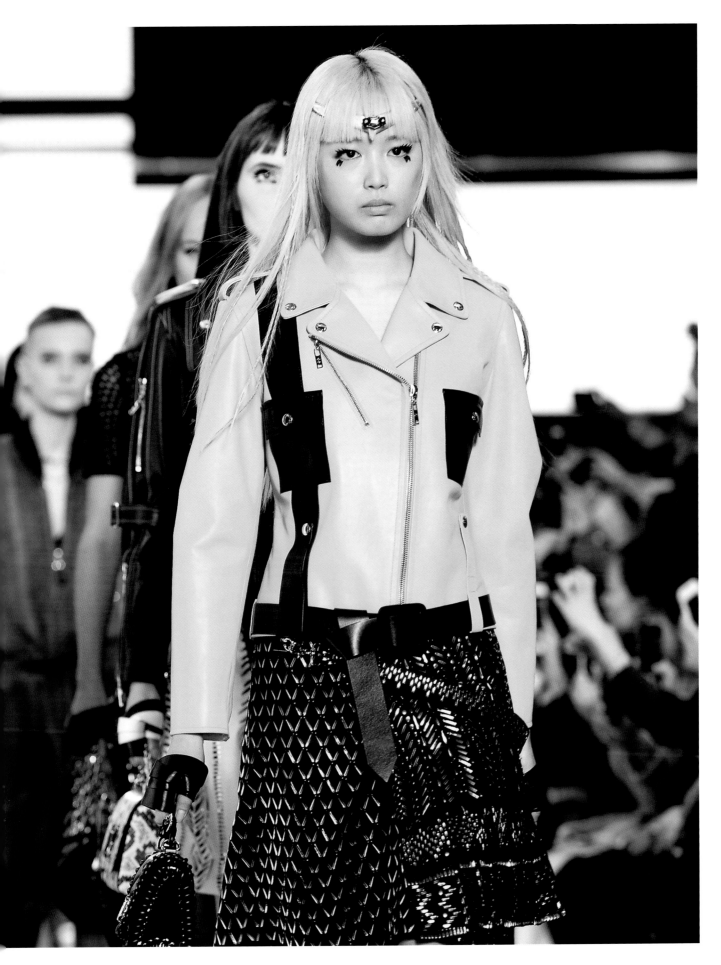

SAINT LAURENT

Paris, Spring/Summer 2016

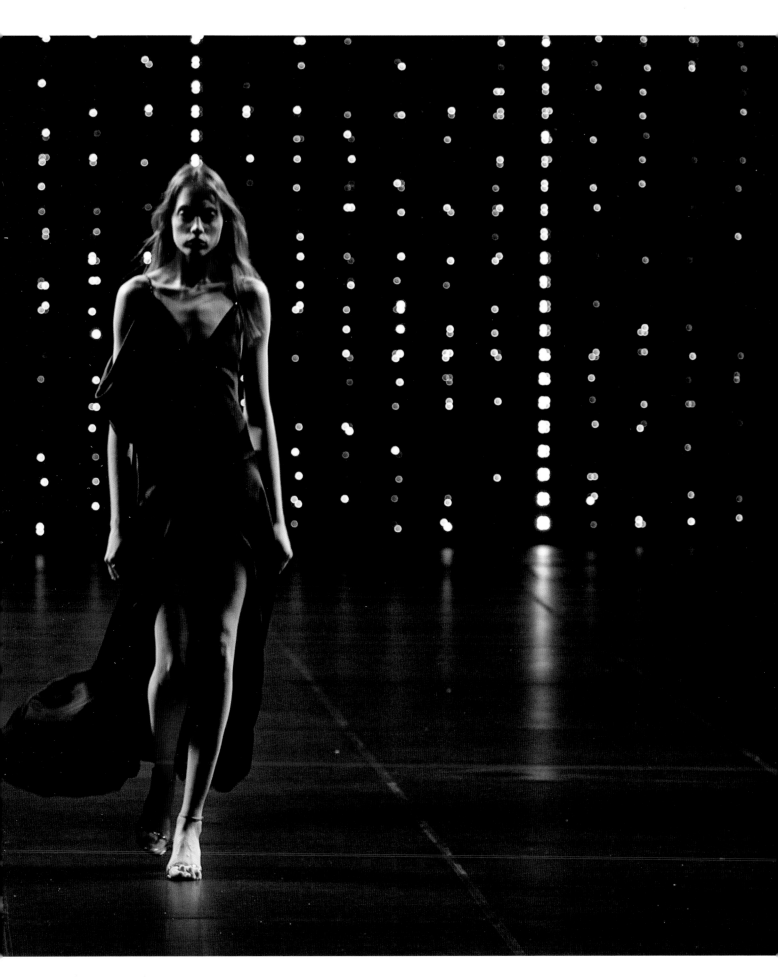

BALENCIAGA

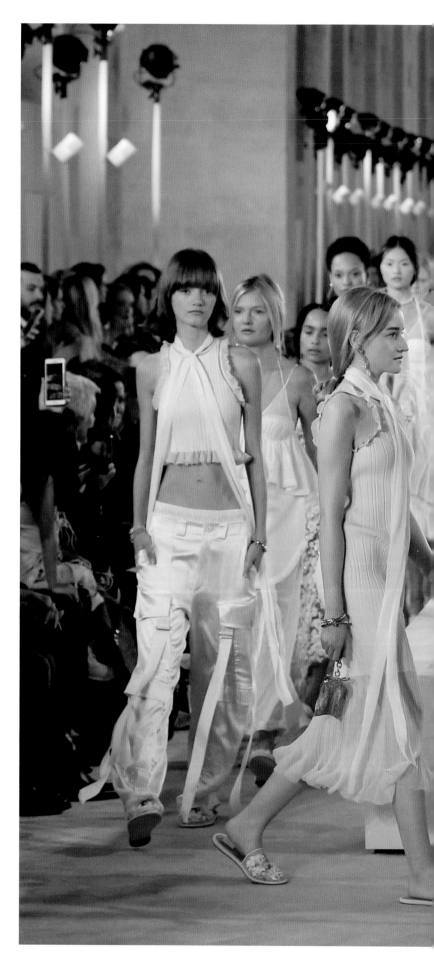

Paris, Spring/Summer 2016

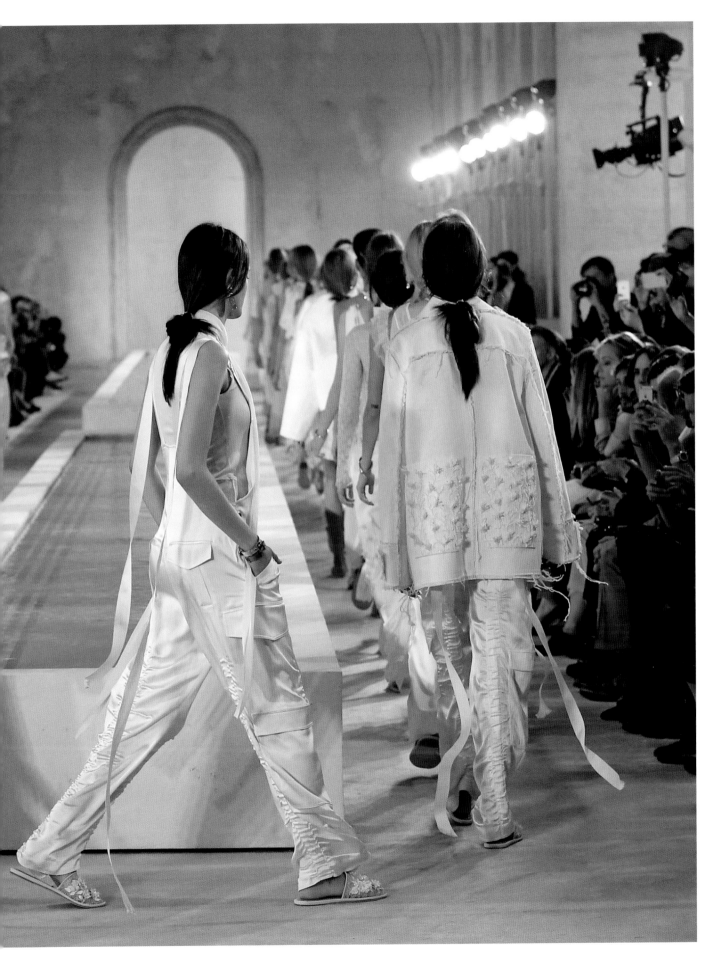

CORINNA WILLIAMS

NINA ZYWIETZ

A typical e-mail from Corinna:
"Hey, have you heard of The Class yet? It's where Gisele Bündchen and Leandra Medine work out these days!"
Umm, nope.
"What about cronuts?! Bulletproof Coffee? You know, the one with the butter?"
Come again?

Corinna Williams, Bavarian, German-American, and new Brooklynite, has, in New York, been sitting next to the meta-phorical trend seismograph, recording even the faintest rumblings of pop culture and their impact on style. In her spare time, she organizes photoshoots with Taylor Swift or Naomi Watts, talks hairdos with Rihanna, and travels to New Orleans and Los Angeles. Not only would I always listen carefully to Corinna's predictions about style, trends, and fashion, I would happily work for her. Really. And not just because I'd like to be closer to that trend seismograph. But because Corinna, who earned her college degree in International Relations and Diplomacy, is one of those people you can always count on. She's like your smart, well-informed BFF. Until she's done building her empire, I'll just keep eating croissants that look like donuts, add butter to my coffee, and do that yoga slash kickboxing slash strength training class. To feel that little bit more fabulous, right here, at home in Germany.

Miriam Stein

I first met Nina Zywietz in the nineties at the Sonar music festival in Barcelona. At the time, she was working on Adidas' comeback, right when the Superstar sneaker was about to be reissued for the first time. We had been introduced by a mutual friend, but lost each other in the crowd about three minutes later. No name, no phone number, no way to connect, that's how things were in the nineties. Six months later, we bumped into each other on the street in Berlin-Kreuzberg. We found out that we had both moved to Bergmannkiez around the same time and lived only two streets apart. This time we managed to exchange names and numbers.
Why I am telling you this? Because I don't know anyone who travels as quickly and as much as Nina does, always just about to embark on her next adventure, eyes wide open and full of curiosity. And she has a style like no one else. Once, some Japanese photographers stopped her on the street and asked if they could take a few pictures of her. A few months later, Nina went on a trip to Japan—only to see herself plastered all over giant billboards in Tokyo.
When I met her in Kreuzberg, she had just moved from Solingen to Berlin. Later, she lived in London, Munich, and Hamburg, always with short stints in Berlin, although I tend to catch her in Los Angeles a lot lately. As a creative director and marketing expert, she has worked in leading positions for national and international brands, publishers, and agencies, and again and again, has been replicating the success she had with Adidas. She has this strategic view on style that only one who simultaneously takes fashion very seriously and not seriously at all can cultivate.
The last time I bumped into her a few weeks ago at the Berlin-Tegel airport, she was wearing a Thrasher hoodie with Prada backpack and was on her way to L.A. for a photoshoot. She told me about this book, the one you're holding in your hands right now, and was excited to show me some layouts on her iPhone. And then she had to run.

Christoph Amend

STOCKISTS

PURE VICTORIA BECKHAM *victoriabeckham.com* CÉLINE *celine.com* JIL SANDER *jilsander.com* CALVIN KLEIN COLLECTION *calvinklein.com* THE ROW *therow.com* RYAN ROCHE *ryan-roche.com* M. MARTIN *mmartin.com* ELLERY *elleryland.com*

ROMANTIC & BOHEMIAN MISSONI *missoni.com; m-missoni.com* ISABEL MARANT *isabelmarant.com* CHLOÉ *chloe.com* VALENTINO *valentino.com* ETRO *etro.com* VANESSA SEWARD *vanessaseward.com* TALITHA *talithacollection.com*

ALL-AMERICAN TORY BURCH *toryburch.com* RALPH LAUREN *ralphlauren.com* TOMMY HILFIGER *global.tommy.com* GANT *gant.com* MICHAEL KORS *michaelkors.com* COACH *world.coach.com* BILL BLASS *billblass.com* EDITH A. MILLER *edithamiller.com*

FEMININE & PLAYFUL MIU MIU *miumiu.com* LANVIN *lanvin.com* MARNI *marni.com* DRIES VAN NOTEN *driesvannoten.be* ALEXANDER MCQUEEN *alexandermcqueen.com* SIMONE ROCHA *simonerocha.com* ISA ARFEN *isaarfen.com* ERDEM *erdem.com*

SPORTY ALEXANDER WANG *alexanderwang.com* ACNE STUDIOS *acnestudios.com* DKNY *dkny.com* LACOSTE *lacoste.com* MONCLER *moncler.com* PUBLIC SCHOOL *publicschoolnyc.com* OFF-WHITE *off---white.com* VETEMENTS *vetementswebsite.com* BMW MOTORRAD *bmw-motorrad.com*

ITALIANS DO IT BETTER DOLCE & GABBANA *dolcegabbana.com* ROBERTO CAVALLI *robertocavalli.com* PUCCI *emiliopucci.com* GUCCI *gucci.com* PRADA *prada.com* STELLA JEAN *stellajean.it* FAUSTO PUGLISI *faustopuglisi.com* MSGM *msgm.it*

DENIM LEVI`S *levi.com* AG ADRIANO GOLDSCHMIED *agjeans.com* DIESEL *diesel.com* J BRAND *jbrandjeans.com* WRANGLER *wrangler.de* BLK DNM *blkdnm.com* R13 *r13denim.com* FRAME *frame-denim.com*

SEXY VERSACE *versace.com* TOM FORD *tomford.com* BALMAIN *balmain.com* MUGLER *mugler.com* GIVENCHY *givenchy.com* ANTHONY VACCARELLO *anthonyvaccarello.com* ALEXANDRE VAUTHIER *alexandrevauthier.com* VERSUS VERSACE *versusversace.com*

AVANT-GARDE COMME DES GARÇONS *comme-des-garcons.com* HAIDER ACKERMANN *haiderackermann.be* YOHJI YAMAMOTO *yohjiyamamoto.co.jp* THOM BROWNE *thombrowne.com* MAISON MARGIELA *maisonmargiela.com* SACAI *sacai.jp* JAQUEMUS *jacquemus.com* HOOD BY AIR *hoodbyair.com*

THE HOUSE OF DIOR *dior.com* CHANEL *chanel.com* LOUIS VUITTON *louisvuitton.com* SAINT LAURENT *ysl.com* BALENCIAGA *balenciaga.com*

CREDITS

© 2016 teNeues Media GmbH & Co. KG

Edited by Corinna Williams & Nina Zywietz

Art Direction: Nina Zywietz
Design by Saskia Ballhausen and Robert Kuhlendahl,
teNeues Media
Texts and Translations by Corinna Williams
Copy editing: Amanda Ennis (English), Pit Pauen and
Inga Wortmann (German), teNeues Media
Editorial coordination by Inga Wortmann, teNeues Media
Production by Alwine Krebber, teNeues Media
Color separation by Medien Team-Vreden

ISBN: 978-3-8327-3370-4

Library of Congress Number: 2015958057

Printed in the Czech Republic

Bibliographic information published by the
Deutsche Nationalbibliothek.
The Deutsche Nationalbibliothek lists this publication
in the Deutsche Nationalbibliografie; detailed bibliographic
data are available in the Internet at http://dnb.d-nb.de.

Published by teNeues Publishing Group

teNeues Media GmbH & Co. KG
Am Selder 37, 47906 Kempen, Germany
Phone: +49-(0)2152-916-0
Fax: +49-(0)2152-916-111
e-mail: books@teneues.com

Press department: Andrea Rehn
Phone: +49-(0)2152-916-202
e-mail: arehn@teneues.com

teNeues Publishing Company
7 West 18th Street, New York, NY 10011, USA
Phone: +1-212-627-9090
Fax: +1-212-627-9511

teNeues Publishing UK Ltd.
12 Ferndene Road, London SE24 0AQ, UK
Phone: +44-(0)20-3542-8997

teNeues France S.A.R.L.
39, rue des Billets, 18250 Henrichemont, France
Phone: +33-(0)2-4826-9348
Fax: +33-(0)1-7072-3482

www.teneues.com

teNeues Publishing Group
Kempen
Berlin
London
Munich
New York
Paris

teNeues